HAMBURG
architecture & design

Edited and written by Christian Datz and Christof Kullmann
Concept by Martin Nicholas Kunz

teNeues

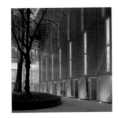

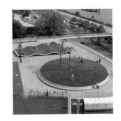

to see . culture & education

to see . public

contents

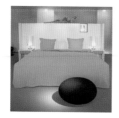
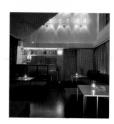

to stay . hotels

to go . eating, drinking, clubbing

to go . wellness, beauty & sport

to shop . mall, retail, showrooms

index

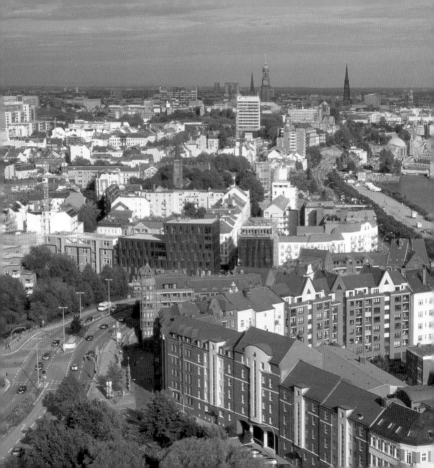

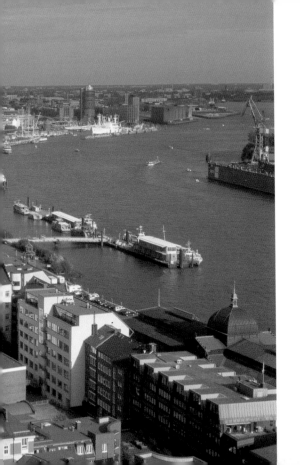

introduction

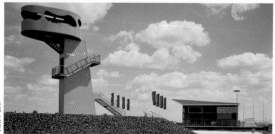

View Point

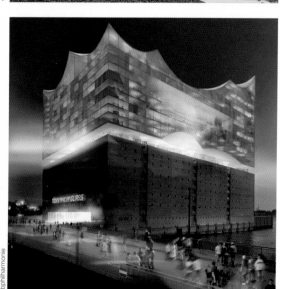

Elbphilharmonie

Die Hansestadt Hamburg ist einer der bedeutendsten Wirtschaftsstandorte in Deutschland. Hier verbindet sich die Tradition der alten Handelsstadt mit dem internationalen Flair einer modernen Metropole. In diesem Umfeld hat sich eine interessante und innovative Architekturszene entwickelt, die eine Vielzahl von außergewöhnlichen Gebäuden hervorgebracht hat. Zudem entsteht mit der HafenCity in Hamburg gegenwärtig eines der spektakulärsten städtebaulichen Entwicklungsprojekte Deutschlands. Der and:guide Hamburg fasst eine Auswahl der wichtigsten aktuellen Bauten und Entwürfe in einem praktischen Führer zusammen und bestätigt einmal mehr den Ruf der Stadt als noble, weltläufige Metropole des Nordens.

The "Hanseatic" city of Hamburg is one of Germany's most important economic centers. Here, the tradition of the old trading city combines with the international flair of a modern metropolis. In this atmosphere, an interesting and innovative architectural scene has developed and produced plenty of exceptional buildings. Also, Hamburg's docks, or "Harbor City", is currently turning into one of Germany's most spectacular urban planning development projects. The and:guide Hamburg includes a range of the most important, contemporary buildings and designs in a practical book that shows once again why this city enjoys a reputation as the stylish, world-class metropolis of the North.

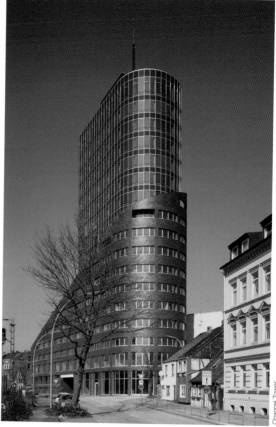

Channel Tower

9

La ville hanséatique de Hambourg est un des centres économiques les plus importants d'Allemagne. C'est ici que se conjuguent la tradition de l'ancienne ville de la Hanse et la touche internationale de la métropole moderne. Une scène architecturale intéressante et innovatrice s'est développée dans ce contexte et a réalisé un grand nombre de constructions exceptionnelles. De surcroît un des projets de développement urbain les plus spectaculaires d'Allemagne est en train de voir le jour actuellement avec la HafenCity de Hambourg. Ce and:guide Hambourg propose de manière pratique un éventail des constructions et projets actuels les plus importants et confirme une fois encore la réputation de métropole du Nord noble et d'envergure internationale de la ville.

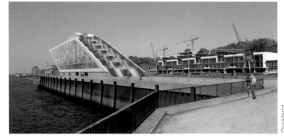
Dockland

La ciudad hanseática de Hamburgo es uno de los centros económicos más importantes de Alemania. Aquí, la tradición de la vieja ciudad de la Hansa, se funde con el estilo internacional de una metrópoli moderna. En este entorno ha surgido una interesante e innovadora escena arquitectónica, origen de un amplio número de excepcionales edificios. Además, con la HafenCity en Hamburgo se está construyendo en la actualidad uno de los proyectos urbanísticos más espectaculares de Alemania. La and:guide Hamburgo reúne en una práctica guía una selección de las construcciones y los proyectos actuales más relevantes, confirmando una vez más su fama de elegante y cosmopolita metrópoli del norte.

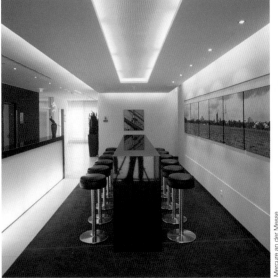
Mercure an der Messe

11

to see . living
office
culture & education
public

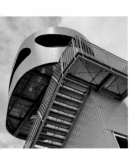
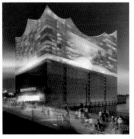
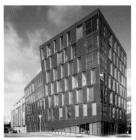
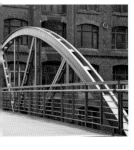
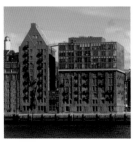
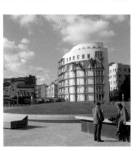
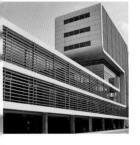
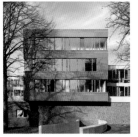
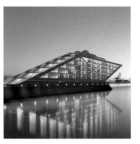

Stadtlagerhaus an der Elbe

Jan Störmer Partner
Assmann Beraten + Planen GmbH

2001
Große Elbstraße 27
Altona

www.stoermer-partner.de
www.assmann-b-p.de

Das Ensemble aus einem Silo- und einem Speichergebäude wurde aufwändig saniert und in eine neue „Landmarke" des Hafens verwandelt. Die auffälligste Veränderung ist ein viergeschossiger, gläserner Aufbau auf dem Speichergebäude, in dem sich 28 Wohnungen mit Größen von 50 m² bis 150 m² befinden.

The ensemble of a silo and warehouse was painstakingly restored and transformed into a new "landmark" in the harbor. The most striking change is a four-storey, glass extension to the storehouse building, where 28 apartments are located, measuring from 50 m² to 150 m².

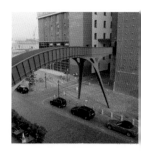

Le complexe constitué d'un silo et d'un bâtiment d'ensilage a été rénové à grands frais pour devenir « l'amer », point de repère géographique du port. La transformation la plus frappante est une superstructure de verre de quatre étages en haut du bâtiment d'ensilage accueillant 28 logements de 50 à 150 m².

Este conjunto formado por un silo y un almacén fue completamente reformado y convertido en un nuevo "hito" del puerto. El cambio más llamativo es la construcción de cristal de cuatro plantas del edificio del almacén, que alberga 28 viviendas de 50 m² hasta 150 m².

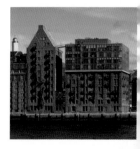

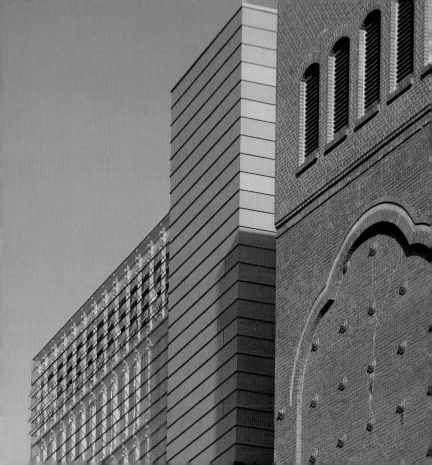

schanzenupgrade

spine² architects
Weber & Poll

2004
Juliusstraße 36-38
Altona

www.spine2.com

Die konvex-konkav geschwungene Straßenfront ist das auffälligste Merkmal der zweigeschossigen Aufstockung. Als äußere Haut wählten die Architekten leicht verformbare, transluzente Acrylglasplatten. Dahinter liegt eine Glasfassade mit einer ebenfalls lichtdurchlässigen Wärmedämmung.

The convex-concave swung structure of the street frontage is the most striking feature of the two-storey extension. The architects chose light, pliable and translucent acrylic glass plates as the exterior skin. A glass façade is behind this surface, with an equally light-diffusing layer of insulation.

La façade en courbes convexes et concaves est la caractéristique la plus ostensible de cette surélévation de deux étages. En guise d'enveloppe extérieure les architectes ont choisi des panneaux de plexiglas translucides. Derrière se trouve une façade de verre dotée d'une isolation thermique également translucide.

La característica más llamativa de esta construcción de dos plantas es la fachada cóncava-convexa que da a la calle. Para el revestimiento exterior, los arquitectos escogieron planchas translúcidas de cristal acrílico ligeramente deformables. Detrás hay una fachada de cristal con un aislamiento térmico que permite también el paso de la luz.

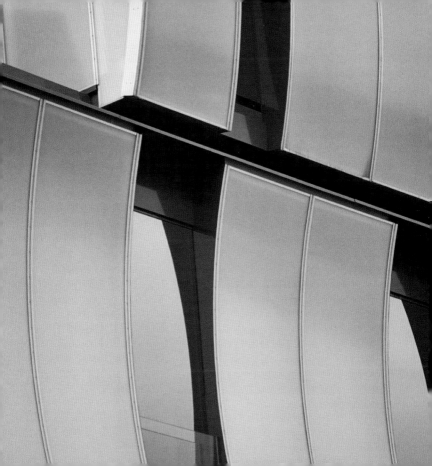

Bogenallee

blauraum architekten

2005
Bogenallee 10-12
Harvestehude

www.blauraum.de

Hervorspringende Boxen prägen die Fassade des Gebäudes – niemand würde vermuten, dass es sich um ein umgebautes Bürohaus aus den 70er-Jahren handelt! Die Bäder und Küchen der 15 Wohnungen wurden ebenfalls als Boxen konzipiert und gliedern die ansonsten offenen Grundrisse in verschiedene Bereiche.

Protruding box structures influence the building's façade—nobody would suspect that they are the result of a 1970s remodeled office block! The bathrooms and kitchens of the 15 apartments were also designed as boxes; and in different areas they create the otherwise open layout.

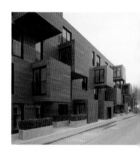

Des cubes en espalier caractérisent la façade du bâtiment – personne ne soupçonnerait qu'il s'agit d'un immeuble de bureaux datant des années 70 transformé. Les salles de bains et cuisines des 15 appartements conçues également comme des cubes articulent les plans par ailleurs ouverts en différents domaines.

La fachada de este edificio se distingue por sus balcones en forma de sobresalientes cajas. ¡Nadie supondría que se trata de un edificio reformado de oficinas de la década de 1970! Los baños y las cocinas de las 15 viviendas fueron concebidos también como cajas y dividen los planos abiertos en diferentes áreas.

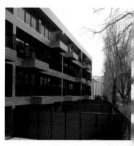

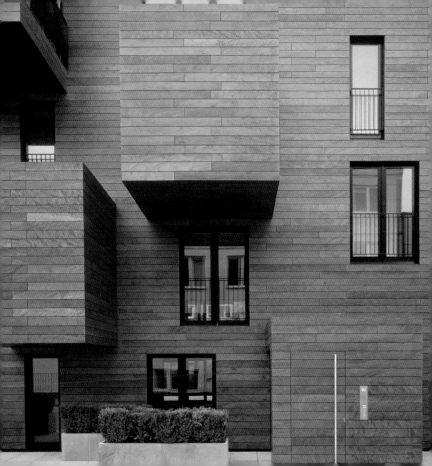

Townhouses Falkenried

Spengler · Wiescholek Architekten Stadtplaner

2004
Straßenbahnring
Hoheluft-Ost
www.spengler-wiescholek.de

Das neue Wohnquartier mit insgesamt 52 Häusern entstand auf dem Gelände eines ehemaligen Straßenbahndepots. Außer den städtebaulichen Konturen des historischen Areals blieben auch Teile der alten Bebauung erhalten: Ganze Fassadenfluchten einschließlich der Hallentore konnten in die neue Stadthausbebauung integriert werden.

The new residential district with a total of 52 houses was created on the site of a former tram depot. Apart from the urban contours of the historical depot, parts of the old building work were also preserved: entire façade alignments, including the entrance gates to the tram sheds could be integrated into the new townhouse development.

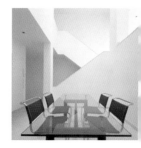

Ce nouveau quartier résidentiel comptant en tout 52 maisons s'est construit sur le terrain d'un ancien dépôt de tramways. En dehors des contours urbanistiques du quartier historique, des parties de l'ancienne construction ont été conservées : des alignements entiers de façades, portes comprises, ont pu être intégrés dans cette nouvelle construction urbaine.

Esta urbanización nueva compuesta por 52 casas se levantó en el solar de un antiguo almacén ferroviario. De la superficie histórica se han conservado los contornos urbanísticos además de elementos de los antiguos edificios: en las construcciones modernas se pudieron integrar líneas completas de fachadas incluyendo los portones de las naves.

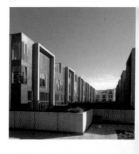

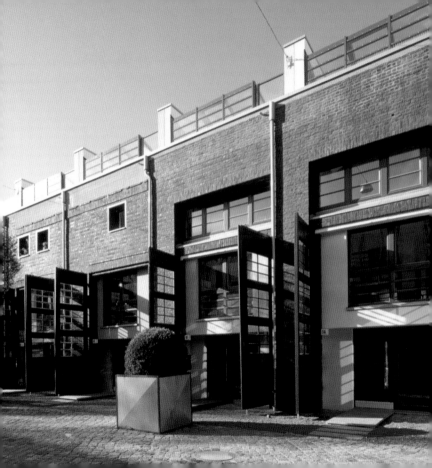

Aßmannkanal

Kleffel Köhnholdt Papay Warncke Architekten

2002
Zeidlerstraße 52
Wilhelmsburg
www.alt-wilhelmsburg.de
www.kkpw.de

Die 42 Reihenhäuser entstanden als Ergebnis eines Wettbewerbs für experimentellen Wohnungsbau. Jedes Reihenhaus besteht aus einem Haupthaus und einem vorgelagerten Gartenhaus. Durch die Überlagerung der Treppenläufe zweier benachbarter Wohneinheiten gelang den Architekten eine Reduzierung der Gebäudebreite auf nur 4,85 m.

The 42 terraced houses were created as the result of a competition for experimental living construction projects. Each property consists of a main house with protruding summerhouse. By overlapping the staircases of two neighboring properties, the architects succeeded in reducing the width of the building to only 4.85 m.

Les 42 maisons mitoyennes sont le résultat d'un concours pour la construction expérimentale de logements. Chaque maison mitoyenne se compose d'une maison principale et d'une maison de jardin placée devant. Grâce à la superposition des cages d'escalier de deux unités d'habitation voisines les architectes ont réussi à réduire la largeur du bâtiment à seulement 4,85 m.

Estas 42 casas adosadas son el resultado de un concurso de construcción experimental de viviendas. Cada chalet se compone de una casa principal con un jardín en la parte delantera. Gracias a la superposición de las escaleras de parejas de casas vecinas, los arquitectos consiguieron reducir el ancho de la construcción a sólo 4,85 m.

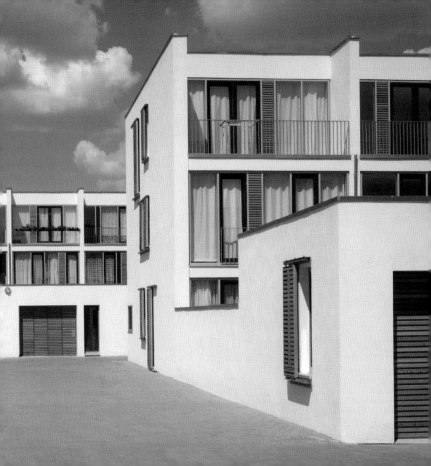

Elbloft

KSP Engel und Zimmermann Architekten

2003
Neumühlen 23
Neumühlen

www.ksp-architekten.de

Der leuchtend weiße Baukörper des Elblofts ruht zur Elbe hin auf Stützen, während der hintere Teil auf einem Sockel liegt, der als sturm- und flutsichere Garage dient. Die Südfassade des L-förmigen Baukörpers ist vollständig verglast – die Wohnungen bieten dadurch einen beeindruckenden Blick über die Elbe und den Hafen.

The bright, white structure of the Elbloft stands on stilts facing the river Elbe, whilst the rear section rests on a plinth, acting both as a storm and flood-proof garage. The south façade of the L-shaped structure is completely glazed—this is how the apartments offer an impressive view across the river Elbe and the harbor.

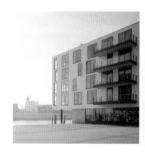

Le corps du bâtiment d'un blanc lumineux de l'Elbloft s'appuie sur des piliers vers l'Elbe tandis que la partie arrière repose sur un socle qui fait fonction de garage résistant aux tempêtes et débordements. La façade sud du corps en forme de L est entièrement vitrée – les appartements ont ainsi une vue impressionnante sur l'Elbe et le port.

La parte orientada hacia el Elba del brillante cuerpo blanco del Elbloft se apoya en pilares, mientras que la parte trasera descansa sobre un zócalo que sirve como garaje protegido de las tormentas e inundaciones. La fachada sur de esta construcción en forma de L está completamente acristalada, por lo que las viviendas disfrutan de una vista impresionante sobre el Elba y el puerto.

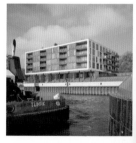

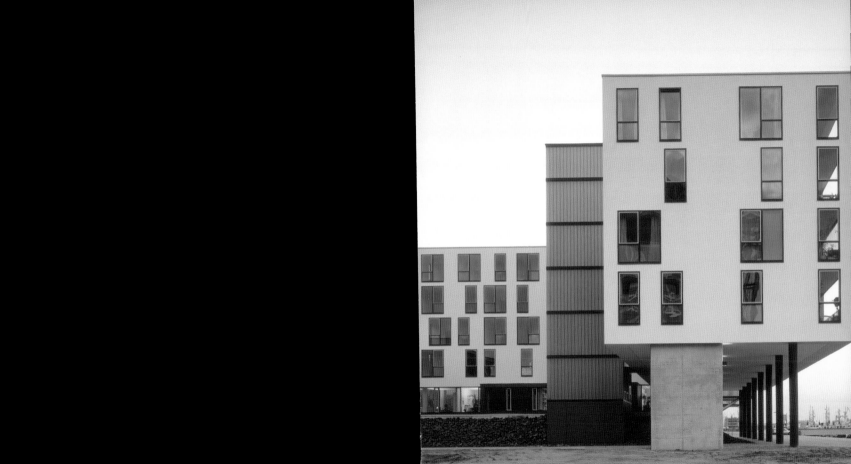

Wohnhaus am Hang

Wacker Zeiger Architekten

2000
Baurs Weg 3
Blankenese

www.wackerzeiger.de

Zwischen den traditionellen Villen des Nobelvororts Blankenese sticht dieser kompromisslos moderne Bau hervor. Zum Hang hin gibt sich das Haus eher geschlossen, mit wenigen schmalen Fenstereinschnitten, zum Tal hin dagegen gewährt eine großflächige Glasfassade eine grandiose Aussicht auf die Elbe.

This uncompromising, modern building stands out amongst the traditional villas of the elegant suburb of Blankenese. Towards the hillside, the house looks more closed up, with a few, narrow window slits, whereas towards the valley, a large glass façade guarantees a splendid view of the Elbe.

Entre les villas traditionnelles du quartier résidentiel de Blankenese se démarque cet intransigeant bâtiment moderne. Côté colline la maison paraît plutôt fermée, avec quelques fentes étroites pour les fenêtres. Par contre, côté vallée, une grande façade de verre offre une vue grandiose sur l'Elbe.

Entre las casas de estilo tradicional del elegante suburbio Blankenese destaca esta perfecta construcción moderna. La vivienda, más bien cerrada hacia la colina con pocas y estrechas ventanas, se abre hacia el valle con una amplia fachada acristalada que permite disfrutar de una bella vista sobre el Elba.

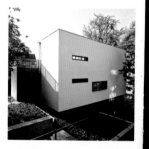

26

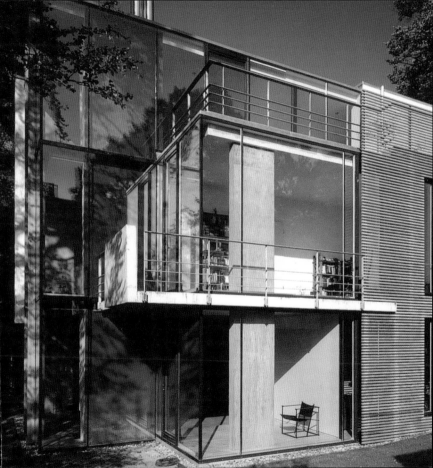

Anna-Hollmann-Weg

Stoeppler + Stoeppler Architekten BDA

2000
Anna-Hollmann-Weg 12
Blankenese

www.stoeppler-architekten.de

Auf einem Hanggrundstück am Elbberg steht diese exklusive Villa eines Hamburger Künstlers. Zwei durch eine Treppe getrennte rechteckige Baukörper mit Wohn- und Atelierräumen bilden den Sockel des Gebäudes. In der darüber liegenden, „geschuppten" Box befinden sich die Schlaf- und Privaträume.

This exclusive villa belonging to a Hamburg artist is located on a hillside plot on the Elbberg. Two rectangular structures, divided by a staircase, with living and studio accommodation form the lower part of the building. The bedrooms and private rooms are located in the "fish-scaled" box, which is situated above.

Sur un terrain en pente de l'Elbberg se trouve la villa très originale d'un artiste hambourgeois. Deux corps de bâtiment rectangulaires abritant l'habitation et l'atelier et séparés par un escalier constituent le socle du bâtiment. Dans le rectangle couvert d'écailles posé au-dessus se trouvent les chambres et les pièces privées.

Esta exclusiva villa propiedad de un artista de Hamburgo se levanta en una ladera. Dos cuerpos rectangulares separados por una escalera, forman el zócalo de la casa y en ellos se alojan los espacios destinados al salón y al estudio. La caja situada encima parece estar recubierta de escamas y alberga los dormitorios y las estancias privadas.

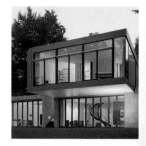

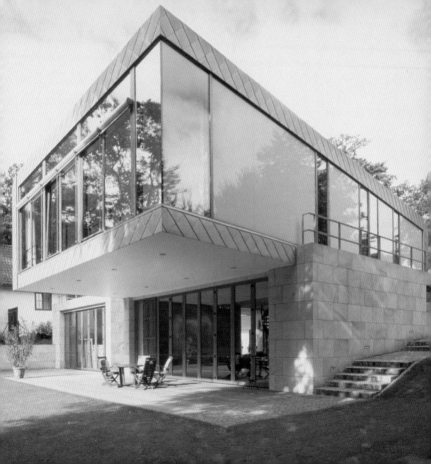

Neuer Wall 59

Antonio Citterio and Partners

2002
Neuer Wall 59
Innenstadt

www.antoniocitterioandpartners.it

Direkt an einer der prominentesten Einkaufsstraßen Hamburgs liegt dieses elegante Geschäfts- und Bürohaus. Die Fassade besteht aus zwei Schichten – einer äußeren Steinfassade und einer dahinter liegenden Ebene aus Fenstern mit hölzernen Rahmen und Schiebeläden.

This elegant commercial and office block is located right on one of Hamburg's main shopping streets. The façade consists of two layers—an outer, stone façade and beneath that a layer of windows with wooden frames and sliding blinds.

Cet élégant immeuble de magasins et de bureaux se situe directement sur l'une des rues commerçantes les plus en vue de Hambourg. La façade se compose de deux couches – une façade extérieure de pierre et un plan arrière constitué de fenêtres avec des cadres de bois et des volets coulissants.

Este elegante edificio de tiendas y oficinas está situado directamente en una de las calles comerciales más famosas de Hamburgo. La fachada se compone de dos capas: una exterior de piedra y un segundo nivel posterior con ventanas de marcos de madera y persianas correderas de lamas.

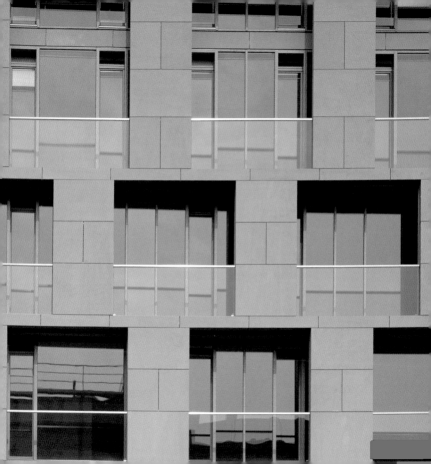

Dock 47

Spengler · Wiescholek Architekten Stadtplaner

2005
Pinnasberg 47
St. Pauli

www.spengler-wiescholek.de

Im heterogenen Umfeld des St.-Pauli-Fischmarkts und dem Pinnasberg dient der expressive Baukörper des Dock 47 als markanter Blickfang. Dazu tragen nicht zuletzt die geneigten Fassadenflächen sowie die leuchtend rote Farbe der Glaspaneele bei.

In the heterogeneous surroundings of the St. Pauli fish market and the Pinnasberg, the expressive structure of Dock 47 serves as a distinctive and eye-catching building. Not least, the sloping façade-elements as well as bright red, glass panels contribute to this.

Dans l'environnement hétérogène du marché aux poissons de St. Pauli et de Pinnasberg, le bâtiment très expressif du Dock 47 accroche immédiatement le regard. Les surfaces inclinées des façades et le rouge lumineux des panneaux de verre y contribuent largement.

En el heterogéneo entorno del mercado del pescado de St. Pauli y el Pinnasberg, la expresiva construcción del Dock 47 es un destacado punto de atención. A esto contribuyen también las superficies inclinadas de las fachadas y los paneles de brillante cristal rojo.

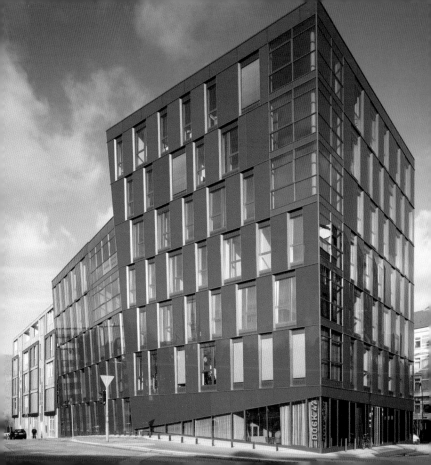

Elbkaihaus

gmp – Architekten von Gerkan,
Marg und Partner
RTI Rüter & Tessnow Ingenieure

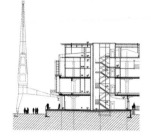

2003
Große Elbstraße 143-145
Neumühlen

www.elbkaihaus.de
www.gmp-architekten.de

Eine ehemalige Etagenkühlhalle wurde in ein modernes Loft-Bürohaus umgebaut. Fassadenrücksprünge und die Lage der neuen Treppenhäuser und Aufzüge gliedern das 130 m lange Gebäude in fünf Abschnitte.

A former cold storage warehouse was remodeled into a modern loft-style office block. The 130 m long building is divided into five sections by recesses in the façade as well as the location of new staircases and elevators.

Un ancien entrepôt frigorifique à étages a été transformé en immeuble moderne de bureaux et de lofts. Des retraits de façade et l'emplacement des nouvelles cages d'escalier et d'ascenseur structurent le bâtiment de 130 m de long en cinq sections.

Una antigua nave frigorífica de varias plantas fue transformada en un edificio de oficinas tipo loft. Los saltos hacia atrás de la fachada y la situación de las nuevas cajas de las escaleras y de los ascensores, dividen este edificio de 130 m de largo en cinco áreas.

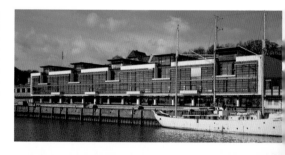

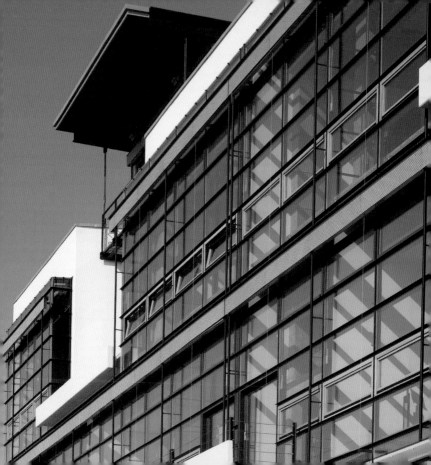

Elbberg Campus

BRT Architekten Bothe Richter Teherani
Dr. Binneweis

2003
Elbberg
Neumühlen

www.elbbergcampusaltona.de
www.brt.de

Der Campus ist ein vielschichtiges Ensemble aus Büro- und Loftgebäuden, in dem sich Wohnen, Arbeiten und Freizeit miteinander verbinden sollen. Die verschiedenen Baukörper staffeln sich entlang des Hangs in einer neu gestalteten Parkfläche und sind durch Spazierwege, Treppen und Terrassen miteinander verknüpft.

The campus is a multi-layered ensemble of office and loft buildings, where living, working and leisure time are meant to be interconnected. The different structures are graduated along the hillside in a newly designed park area; and walkways, stairs and terraces link them to each other.

Le Campus est un ensemble sur plusieurs niveaux de lofts et de bureaux ayant pour but de combiner lieux de vie, de travail et de loisirs. Les différents corps de bâtiment s'étagent sur la colline dans un parc remodelé et sont reliés par des allées pour la promenade, des escaliers et des terrasses.

El campus es un conjunto de varias capas de edificios de oficinas y viviendas tipo loft donde se quiere unir el vivir con el trabajo y el tiempo libre. Los diferentes volúmenes se apilan a lo largo de la pendiente, en un parque rediseñado, y se interconectan a través de sendas, escaleras y terrazas.

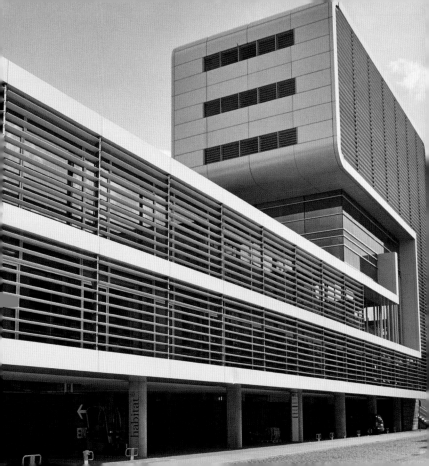

Dockland

BRT Architekten Bothe Richter Teherani

2005
Van-der-Smissen-Straße /
Fischereihafen
Neumühlen

www.dockland-hamburg.de
www.brt.de

Dem exponierten Standort des Gebäudes am Kopf des Edgar-Engelhard-Kais entspricht seine extravagante Form: Schiffsgleich ragt der schräge „Bug" mehr als 40 m weit über die Kaimauer und die Wasserfläche hinaus. Das „Heck" ist als öffentliche Freitreppe konzipiert, über die Besucher eine Aussichtsterrasse und das Restaurant auf dem Dach des Bauwerks erreichen können.

The exposed location of the building at the head of the Edgar-Engelhard Quay matches its extravagant form: the sloping "bow" resembles a ship and rises more than 40 m above the harbor wall and surface of the water. The "stern" is designed as a public staircase that enables visitors to access a viewing terrace and the restaurant on the roof of the structure.

La forme du bâtiment est aussi extravagante que sa position est exposée, à la tête du quai Edgar-Engelhard : tel un navire, sa proue biseautée dépasse sur plus de 40 m du mur du quai et de la surface de l'eau. Sa poupe est conçue comme un perron accessible au public qui permet aux visiteurs d'accéder à une terrasse panoramique et au restaurant situés sur le toit de l'édifice.

El expuesto lugar donde se levanta el edificio, al comienzo del muelle Edgar-Engelhard-Kai, se corresponde con su extravagante forma: como si de un barco se tratara, la inclinada "proa" asciende más de 40 m sobre el muro del muelle y de la superficie del agua. La "popa" ha sido concebida como una escalera abierta a través de la que los visitantes pueden llegar a una terraza panorámica y al restaurante de la azotea del edificio.

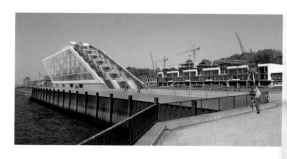

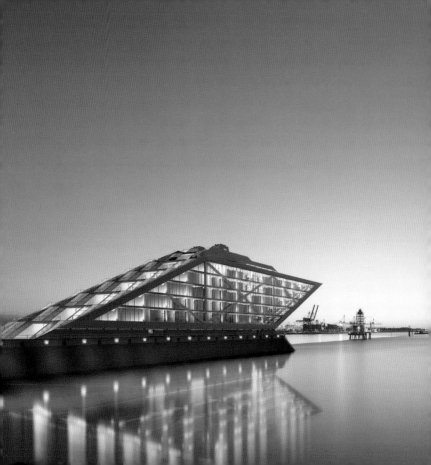

Neumühlen 19

BRT Architekten Bothe Richter Teherani
Dr. Binneweis

2002
Neumühlen 19
Neumühlen

www.brt.de

Das U-förmige Gebäude mit seinen durchlaufenden Glaswänden und der Geschossunterteilung mit schmalen Aluminiumbändern dient als Firmensitz einer renommierten Hamburger Reederei. Eine Reminiszenz an die Architektur der 50er Jahre findet man in den abgerundeten Ecken, die dem Gebäude einen Eindruck von Leichtigkeit verleihen.

The U-shaped building, with its glass walls throughout and floor delineation with thin aluminum strips, serves as the company headquarters of a famous Hamburg shipping enterprise. You notice the influence of 1950s architecture in the rounded corners, which give the building an air of lightness.

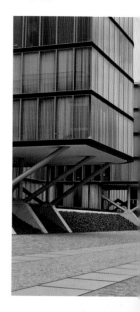

Ce bâtiment en U, avec ses façades entièrement vitrées et ses étages divisés par d'étroites lamelles d'aluminium, héberge le siège d'une compagnie maritime hambourgeoise renommée. Les coins arrondis qui confèrent au bâtiment une impression de légèreté sont une réminiscence de l'architecture des années 50.

Este edificio con forma de U, sede de una famosa compañía naviera de Hamburgo, se caracteriza por sus mamparas continuas de cristal y la división de las plantas con delgados flejes de aluminio. Las esquinas redondeadas son una reminiscencia de la arquitectura de la década de 1950 y dotan al edificio de una cierta ligereza.

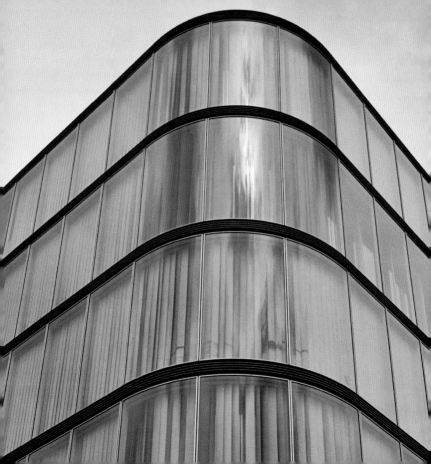

BTC Berliner Tor Center

Jan Störmer Partner
Philipp Holzmann Planungsgesellschaft

2004
Beim Strohhause 31
St. Georg

www.stoermer-partner.de

Ein vorhandenes Hochhaus (das ehemalige Polizeipräsidium) wurde um zwei weitere Türme mit insgesamt 75.000 m² Geschossfläche ergänzt. Die geschickte Gliederung der Volumen in horizontale und vertikale Gebäudeteile wird durch ein subtiles Spiel unterschiedlich breiter Farbstreifen ergänzt.

An existing high-rise building (the former police headquarters) was extended by adding two further towers, with a total of 75,000 m² floor space. The skilful structuring of the proportions in horizontal and vertical building sections is supplemented by a subtle play of colored strips, which measure different widths.

Un immeuble existant (l'ancienne préfecture de police) s'est vu adjoindre deux tours constituant une surface utile de 75 000 m². La distribution adroite des volumes en sections de bâtiment horizontales et verticales se complète d'un subtil jeu de rayures colorées de différentes largeurs.

El edificio de gran altura existente (la antigua Jefatura Superior de Policía) se complementó con otras dos torres con una superficie total de 75.000 m². La inteligente división del volumen en elementos arquitectónicos horizontales y verticales, se completa con un sutil juego de franjas de colores de diferentes grosores.

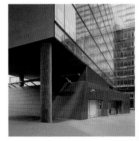

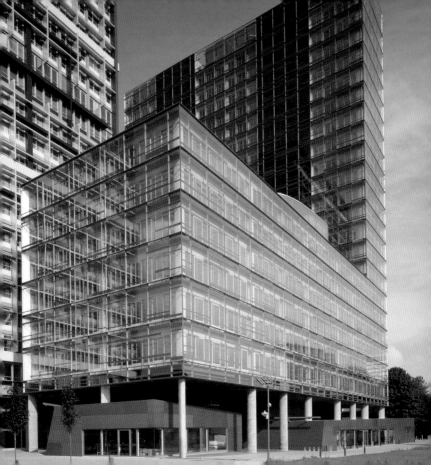

The Posthouse AG

SHE_arch

2002
Poelchaukamp 8
Winterhude

www.the-posthouse.de
www.she-arch.com

Drei Altbauten, in denen ehemals ein Möbelhaus untergebracht war, sind nun Sitz eines der modernsten Studios für digitale Filmbearbeitung. Im Zentrum liegt ein zweigeschossiger Aufenthalts- und Entspannungsraum, von dem aus die Mitarbeiter ihre großzügigen Arbeitssuiten erreichen.

Three old buildings that previously housed a furniture warehouse are now the headquarters for one of the most modern studios for digital film processing. A two-storey rest and relaxation room is located in the center. From here, employees can access their spacious office suites.

Trois immeubles anciens occupés autrefois par un magasin de meubles sont aujourd'hui le siège de l'un des studios de traitement numérique du film les plus modernes. Au centre il y a un espace de détente et de rencontre sur deux étages d'où les collaborateurs rejoignent leurs larges salles de travail.

Las tres antiguas construcciones habían sido una tienda de muebles. En la actualidad albergan la sede de unos modernos estudios para el procesamiento digital de películas. En el centro de la edificación se sitúa una sala de dos pisos a modo de sala de estar y de descanso desde la que los empleados pueden dirigirse a sus amplios despachos.

Ärzte- und Geschäftshaus
Alsterdorfer Markt

wrs architekten winckler röhr-kramer + prof. stabenow

2003
Alsterdorfer Markt 4
Alsterdorf

www.wrs-architekten.de

Das neue Ärzte- und Bürogebäude besticht durch ein anspruchsvolles Farb- und Materialkonzept: Der Sockel ist mit dunklen Torfbrandziegeln verkleidet, in den darüber liegenden Baukörpern kontrastieren weiße Putzflächen mit den warmen Holztönen der Fassadenverkleidung und den farbigen Sonnenblenden.

The new doctors' and office building is noticeable for its sophisticated design of color and material: the base is clad in dark redbrick; and the structures above offer a contrast of white, plaster-work areas with warm wood tones in the façade's cladding and colorful sun blinds.

Le nouvel immeuble de cabinets médicaux et de bureaux éblouit par l'emploi exigeant des matériaux et des couleurs : le socle est habillé de briques de tourbe cuites sombres ; dans les corps de bâtiment supérieurs, les surfaces au crépi blanc contrastent avec les tons chauds du revêtement en bois de la façade et les pare-soleil colorés.

El nuevo edificio de consultas médicas y despachos seduce por su refinado concepto del color y el material. El zócalo está revestido con ladrillos oscuros de turba y, en los cuerpos superiores, las superficies de revoque blanco contrastan con los cálidos colores del revestimiento de madera de la fachada y los coloridos parasoles.

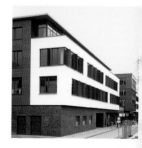

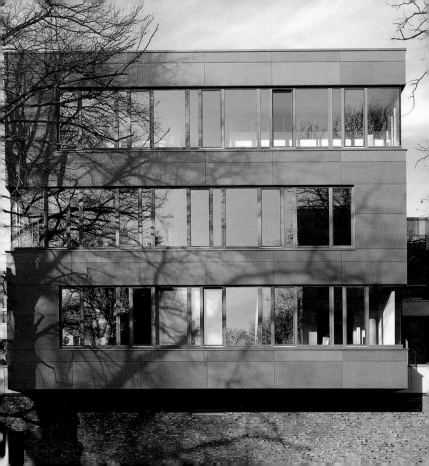

Das Silo

Architekten v. Bassewitz Limbrook Partner

2004
Schellerdamm 16
Harburg

www.das-silo.de
www.architekten-blp.de

Aus einem ehemaligen Getreide-speicher im Harburger Binnen-hafen wurde ein modernes Bü-rohaus. Zehn der ehemals 16 Silozellen wurden dazu abgebro-chen, die sechs verbliebenen nach innen geöffnet und nach außen mit Fenstern versehen. Zwischen und über diesen Silo-Relikten liegen Bürogeschosse hinter einer strengen Stahl-Glas-Fassade.

A modern office block was created out of a former cereal storehouse in Harburg's domestic harbor. Ten of the former 16 interconnecting silos were pulled down for that purpose, while a shared, interior space was created out of the six remaining silos and windows were added on the outside. Between and above these silo relics, office space is located behind a sturdy steel and glass façade.

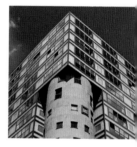

Un ancien silo à blé du port fluvial de Harburg a été transformé en immeuble de bureaux modernes. Dix des 16 silos existants ont ainsi été cassés, les six restants ont été ouverts sur l'intérieur et dotés de fenêtres sur l'extérieur. Entre les vestiges de ces silos et au-dessus s'intègrent plusieurs étages de bureaux derrière une austère façade de verre et d'acier.

Un antiguo almacén de trigo del puerto fluvial de Harburg fue conver-tido en un moderno edificio de ofici-nas. Diez de los antiguamente 16 compartimentos en los que se divi-día el silo desaparecieron, y los seis restantes se unieron hacia el interior dotándoles de ventanas hacia el exterior. Por encima y entre estos vestigios del silo están situados los pisos de los despachos, detrás de la sobria fachada de acero y cristal.

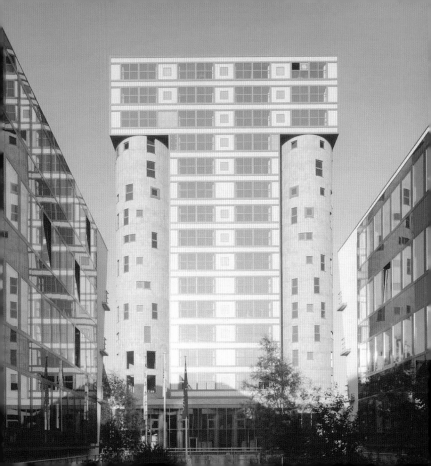

Channel Tower

Prof. Bernhard Winking Architekten BDA

2002
Karnapp 20 / Schellerdamm
Harburg

www.channeltower.de
www.winking.de

Tradition und Moderne verbinden sich hier auf eine ungewöhnliche Art: Eine dunkle Klinkerwand scheint sich gleichsam um ein Hochhaus mit Aluminium-Glas-Fassade herumzuwickeln. Mit diesem Trick gelingt die Überleitung von den dreigeschossigen Nachbargebäuden zu dem neuen Akzent in der Stadtsilhouette von Harburg.

Here, tradition and modernity combine in an unusual way: a dark, clinker wall also seems to wrap itself around a high-rise building with an aluminum and glass façade. This trick facilitates the successful transition from the three-storey neighboring buildings to the new accent in Harburg's city skyline.

Ici la tradition et le moderne sont conjugués de manière inhabituelle : un mur sombre de brique recuite s'enroule pour ainsi dire autour d'une tour à la façade de verre et d'aluminium. Ce moyen assure une transition réussie avec les bâtiments voisins de trois étages, posant ainsi un nouveau jalon dans la silhouette urbaine de Harburg.

La tradición y la modernidad se funden aquí de una forma poco usual: Una pared oscura de ladrillo de clinquer parece como si envolviera un rascacielos de fachada de aluminio y cristal. Con este truco se consigue la transición entre los edificios vecinos de tres plantas y el nuevo monumento del perfil de la ciudad de Harburg.

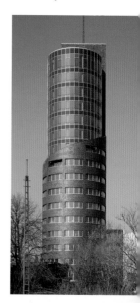

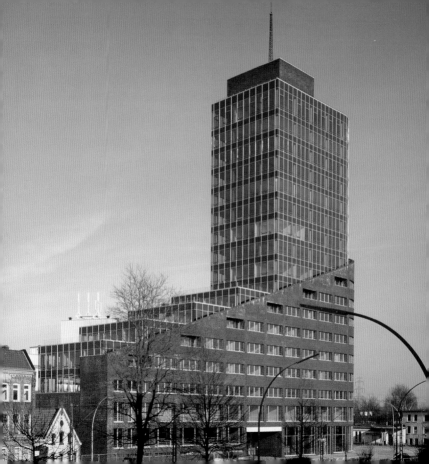

Lundbeck GmbH & Co.

Hennings Börn Interiors
Office Objekt Hamburg

2002
Karnapp 25
Harburg

www.lundbeck.de
www.hennings-boern.de

Die Repräsentanz eines dänischen Pharmaunternehmens umfasst vier Etagen im Channel Tower. Spezieller Wert wurde auf die Gestaltung der gemeinschaftlich genutzten Bereiche gelegt: In jedem Geschoss gibt es Meeting Points für kleine Besprechungen, deren Gestaltung den Seestern im Firmenlogo aufnimmt.

The headquarters of a Danish pharmaceutical company takes up four floors in the Channel Tower. Special emphasis was placed on the design of communally used areas: there are meeting points on every floor for informal discussions; and the starfish in the company's logo adopts their design.

La représentation d'une entreprise pharmaceutique danoise occupe quatre étages de la Channel Tower. Une importance particulière a été accordée à l'organisation des parties communes : à chaque étage, il y a des points de rencontre pour de petites réunions dont l'agencement reprend l'étoile de mer figurant sur le logo de la société.

Una empresa danesa farmacéutica ocupa cuatro pisos en la Channel Tower. Se le dio un valor especial al diseño de los espacios de uso común: en cada planta hay puntos de encuentro para breves reuniones y en su decoración se recoge la estrella de mar del logotipo de la empresa.

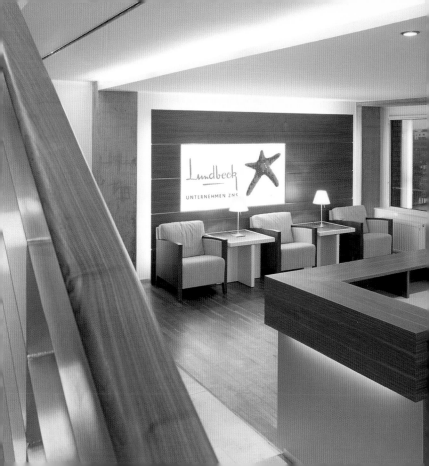

Tobias Grau

BRT Architekten Bothe Richter Teherani

2001
Siemensstraße 35b
Rellingen

www.tobias-grau.com
www.brt.de

Die Firmengebäude des Hamburger Leuchtenherstellers wirken wie zwei riesige Rohre, die durch einen Zwischenbau verbunden sind. Die ungewöhnliche Form wurde mit relativ geringem Aufwand erzeugt: Gebogene Leimholzträger bilden die Primärkonstruktion, die mit einer Fassade aus Aluminiumpaneelen verkleidet ist.

The company buildings of the Hamburg lighting manufacturer look like two giant pipes, which are connected by an intermediate building. The unusual shape was achieved with relatively little effort: the primary construction is formed by glued laminated timber supports that are clad in a façade of aluminum panels.

Les immeubles de la société du fabricant de lustres hambourgeois font l'effet de deux énormes tuyaux raccordés par un module intermédiaire. La forme inhabituelle a été obtenue par des moyens relativement simples : des supports en bois plaqué courbés constituent la construction primaire qui est revêtue d'une façade de panneaux d'aluminium.

Los dos edificios de esta empresa de Hamburgo fabricante de lámparas parecen dos enormes tubos unidos por una construcción intermedia. No costó mucho conseguir esta inusual forma: Vigas de madera encolada forman la construcción primaria, que está revestida con una fachada de paneles de aluminio.

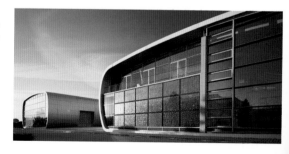

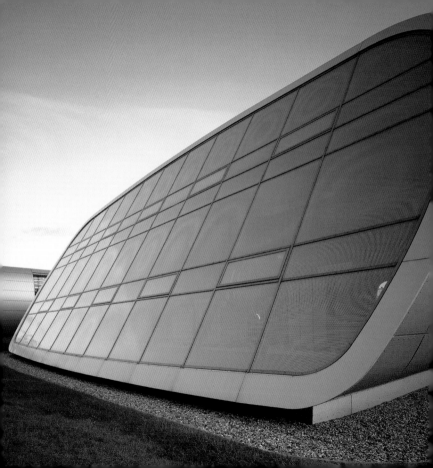

Bucerius Kunst Forum

Jan Störmer Partner
Weber & Poll

2002
Rathausmarkt 2
Innenstadt

www.buceriuskunstforum.de
www.stoermer-partner.de

Die ehemaligen Räume einer Bank am Rathausmarkt wurden zu einem neuen „Treffpunkt für kulturelle Kommunikation" umgebaut. Die modernen Einbauten stehen in einem spannenden und respektvollen Kontrast zur neoklassizistischen Architektur des historischen Gebäudes.

The former offices of a bank on the market square by the Town Hall were remodeled into a new "meeting place for cultural communication". The modern installations are an exciting and respectful contrast to the neo-classicist architecture of the historic building.

Les anciens locaux d'une banque située sur le Rathausmarkt ont été remodelés en « point de rencontre pour la communication culturelle ». Les éléments modernes créent un contraste captivant et respectueux avec l'architecture néoclassique du bâtiment historique.

Los antiguos locales de un banco en el Rathausmarkt (mercado del ayuntamiento) se han transformado en un "nuevo punto de encuentro para la comunicación cultural". Las modernas instalaciones establecen un interesante y respetuoso contraste con la arquitectura neoclásica de este edificio histórico.

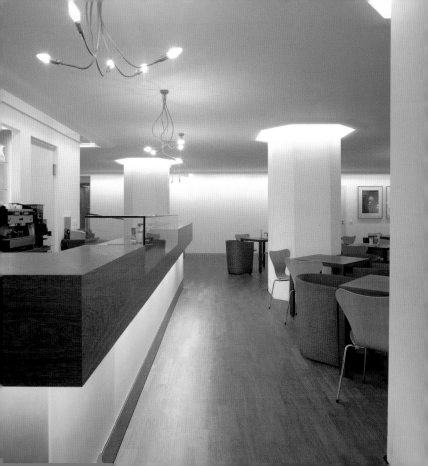

Elbphilharmonie

Herzog & de Meuron

2009
Kaispeicher A Kaiserhöft
HafenCity

Die neue Philharmonie ist nicht nur als Haus für die Musik, sondern als vielschichtiger Wohn- und Kulturkomplex geplant. Dazu gehören eine Konzerthalle und ein Kammermusiksaal, die von einem 5-Sterne-Hotel, Restaurants, Wellness- und Konferenzräumen sowie einer Reihe von Luxuswohnungen ummantelt sind.

The new Philharmonia is not only planned as a house of music, but also as a multi-layered living and cultural complex. A concert hall and chamber music room is included. A five-star hotel, restaurants, fitness and conference space as well as a series of luxury apartments surround them.

La nouvelle Philharmonie n'est pas seulement un projet de temple de la musique mais aussi de complexe culturel et résidentiel aux multiples facettes. Il comprend un hall de concert et une salle de musique de chambre, entourés d'un hôtel cinq étoiles, de salles de conférences et de remise en forme ainsi que d'une série d'appartements de luxe.

La nueva filarmónica no ha sido diseñada solamente para la música, más bien fue proyectada como un complejo de vida y cultura formado por varias capas. En él encontramos una sala de conciertos y otra para música de cámara, rodeadas por un hotel de cinco estrellas, restaurantes, centros de wellmess y salas de conferencias, así como por una serie de viviendas de lujo.

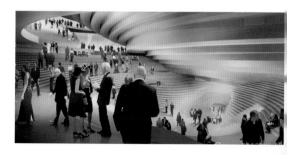

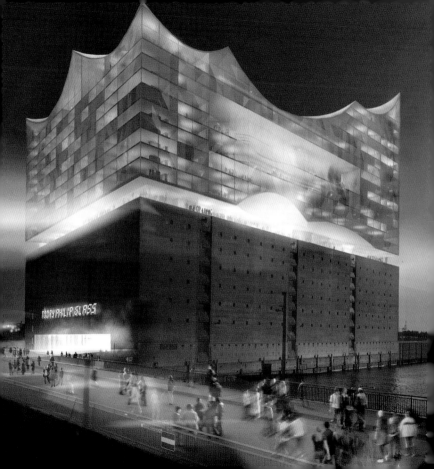

Bucerius Law School
Auditorium Maximum

MEDING PLAN + PROJEKT GmbH

2003
Jungiusstraße 6
Innenstadt

www.mpp-hamburg.de

Wie ein kleiner Tempel steht das Hörsaalgebäude auf dem Campusgelände. Seine Grundrissform entspricht einem so genannten Reuleaux-Dreieck – einer geometrischen Figur, die von drei Kreisbögen begrenzt wird. Der eigentliche Baukörper des Hörsaals wird von einer filigranen Glaskonstruktion umhüllt.

The building that houses the lecture theaters is like a small temple on the campus site. The form of its layout corresponds to a so-called 'Reuleaux' Triangle—a geometrical figure that is limited by three circular arcs. The actual building structure of the lecture theater is wrapped in a filigree glass construction.

Le bâtiment abritant l'amphithéâtre se dresse tel un petit temple sur le campus. La forme de sa base correspond à ce qu'on appelle un triangle de Reuleaux – une figure géométrique limitée par trois arcs de cercle. Le corps proprement dit de l'amphithéâtre est enveloppé d'une construction de verre en filigrane.

El edificio del auditorio parece un pequeño templo en el campus. Su plano es el de un triángulo de Reuleaux, una figura geométrica limitada por tres arcos de círculo. La verdadera construcción del auditorio está envuelta por una construcción de filigrana de cristal.

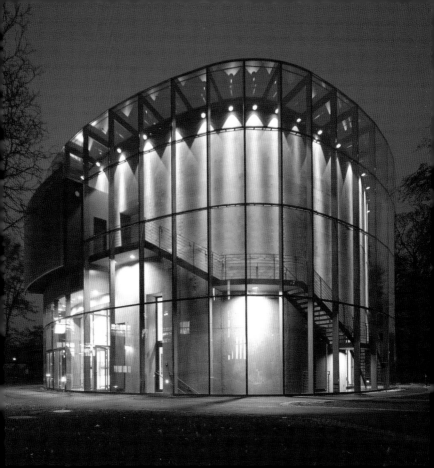

Museum für
Kunst und Gewerbe
„Schümann Flügel"

Jan Störmer Partner
WTM Windels Timm Morgen

2000
Steintorplatz 1
Innenstadt

www.mkg-hamburg.de
www.stoermer-partner.de
www.wtm-ingenieure.de

Der moderne Erweiterungsbau wurde in den Innenhof des Museums für Kunst und Gewerbe eingefügt. Vor der Außenwand des Neubaus hängt ein feines, glitzerndes Stahlgewebe, das in reizvollem Kontrast zu den Fassaden des historischen Gebäudes steht.

The modern extension was added in the inner courtyard of the Museum for Art and Crafts. A fine, glittering steel web is suspended in front of the external wall of the new building. This forms a charming contrast to the façades of the historical building.

L'agrandissement moderne du Musée des Arts et Métiers a été incorporé dans la cour intérieure. Devant le mur extérieur de l'extension est suspendue une fine toile métallique scintillante qui crée un contraste séduisant avec les façades du bâtiment historique.

El moderno edificio anexo se levantó en el patio interior del Museo para el Arte y la Industria. En la pared exterior de esta nueva construcción cuelga una fina y brillante malla de acero con la que se establece un interesante contraste con las fachadas del edificio histórico.

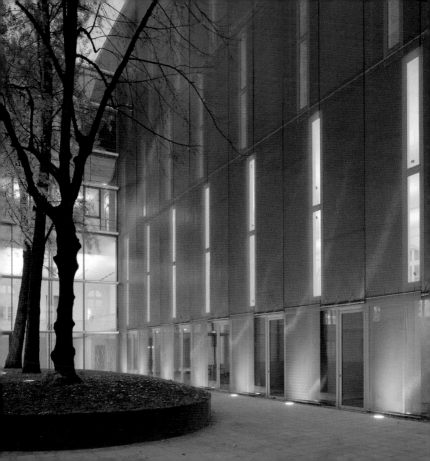

Erotic Art Museum

Jan Störmer Partner
Assmann Beraten + Planen GmbH

1997
Nobistor 10 / Reeperbahn
St. Pauli

www.eroticartmuseum.de
www.stoermer-partner.de
www.assmann-b-p.de

Wo sonst als auf der Reeperbahn könnte dieser ungewöhnliche Museumsbau stehen? Auf einem 100 m langen, aber nur 12,5 m breiten Grundstück verbinden sich neue Baukörper mit den Gebäuden einer ehemaligen Hutfabrik zu einem interessanten, spannungsreichen Ensemble.

Where else could this unusual museum construction be located but on Hamburg's Reeperbahn? New structures combine with the buildings belonging to a former hat factory on a plot measuring 100 m long, but only 12.5 m wide, thus creating an interesting and exciting ensemble.

Où pourrait se trouver cet inhabituel musée si ce n'est sur la Reeperbahn ? Sur un terrain de 100 m de long mais seulement 12,5 m de large, des modules nouvellement construits reliés aux bâtiments d'une ancienne fabrique de chapeaux forment un ensemble intéressant et passionnant.

¿Dónde si no en la Reeperbahn podría estar el inusual edificio de este museo? Sobre un terreno de 100 m de largo y sólo 12,5 m de ancho, las nuevas construcciones se unen con los edificios de una antigua fábrica de sombreros dando lugar a un conjunto arquitectónico interesante y lleno de tensión.

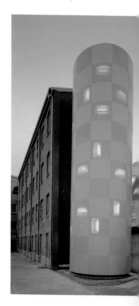

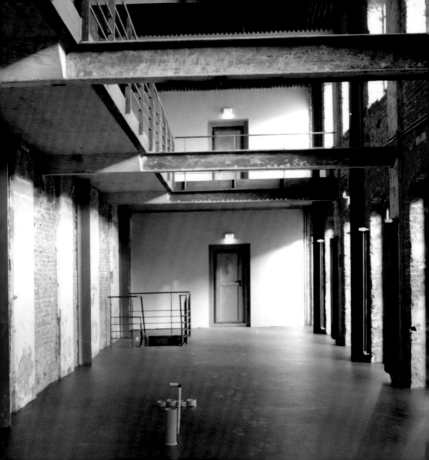

Zentralbibliothek Recht
Central Law Library

me di um Architekten Roloff · Ruffing + Partner
Assmann Beraten + Planen GmbH

2004
Rothenbaumchaussee 33
Rotherbaum

www.medium-architekten.de
www.assmann-b-p.de

Die Bibliothek ist als „kompakter Bücherturm" konzipiert, der über einen kleinen Hof mit den bestehenden Universitätsbauten verbunden ist. Die Fassade setzt sich aus verschiedenfarbigen Glasfeldern zusammen und ändert je nach Lichteinfall, Tages- und Jahreszeit ihr Erscheinungsbild.

The library is designed as a "compact tower of books" that is connected to the existing university buildings by a small courtyard. The façade is made up of different colored glass fields and changes its appearance according to the fall of the light, the time of day and year.

La bibliothèque est conçue comme une « tour des livres compacte » reliée aux autres bâtiments de l'université par une petite cour. La façade est composée de panneaux vitrés de différentes couleurs si bien que son aspect varie selon la diffusion de la lumière, l'heure de la journée et l'époque de l'année.

La biblioteca ha sido diseñada como una "compacta torre de libros" unida a los existentes edificios de la universidad a través de un pequeño patio. La fachada, compuesta por paneles de cristal de diferentes colores, cambia su aspecto en función de la incidencia de la luz, el momento del día y de la estación del año.

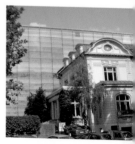

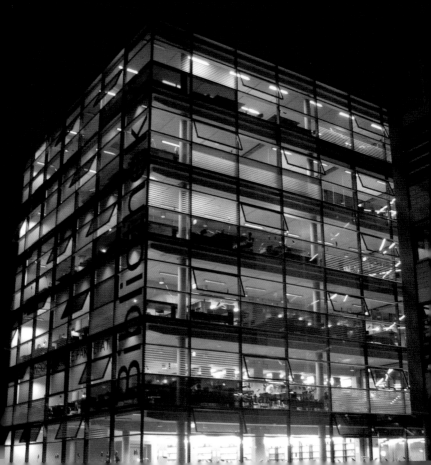

Staatsarchive der Freien und Hansestadt Hamburg
Federal Archive

Jan Störmer Partner

1997
Kattunbleiche 19
Wandsbek

www.stoermer-partner.de
www.staatsarchiv.hamburg.de

Magazin und Verwaltungsbau des Archivs sind als eigenständige, formal unterschiedliche Baukörper konzipiert. Mit seiner fensterlosen Fassade wirkt das Magazin wie ein geheimnisvoller Schrein – historische Dokumente, stark vergrößert auf die Fassade gedruckt, erlauben jedoch Rückschlüsse auf Funktion und Inhalt des Baus.

The archive and its administrative building are designed as independent, formally different structures. The archive space has a windowless façade and appears like a mysterious shrine—heavily magnified historical documents are printed on the façade, enabling conclusions to be drawn about the function and content of the building.

La salle des archives et le bâtiment administratif sont conçus comme des bâtiments indépendants formellement distincts. Avec sa façade aveugle la salle des archives évoque une mystérieuse châsse-reliquaire – grâce aux documents historiques très agrandis et imprimés sur la façade on déduit aisément la fonction et le contenu du bâtiment.

Los edificios de la revista y de la administración del archivo fueron concebidos como dos cuerpos independientes y formalmente diferentes. Con su fachada carente de ventanas, el edificio de la revista parece un misterioso cofre, sin embargo, las grandes ampliaciones de los documentos históricos estampadas en la fachada permiten adivinar la función y el contenido del edificio.

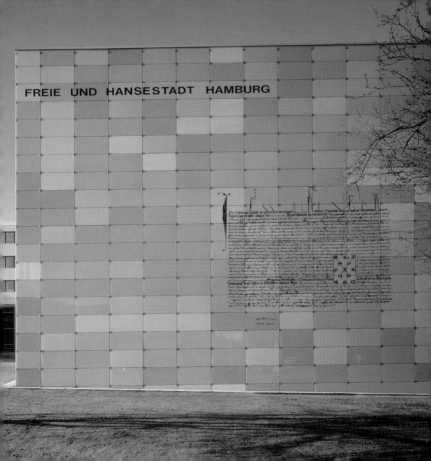

HSV Museum
Hamburg Sports' Club (HSV) Museum

Studio Andreas Heller GmbH

2001
Sylvesterallee 7
Bahrenfeld

www.hsv.de
www.studio-andreas-heller.de

Das Fußballmuseum in der AOL-Arena führt die Besucher auf einen spannenden Rundgang durch die Geschichte des 1887 gegründeten Traditionsvereins. Mit Hilfe des Ausstellungsdesigns sollen sachliche Informationen und darüber hinaus die emotionalen Höhepunkte der Vereinsgeschichte vermittelt werden.

The football museum in the AOL Arena takes the visitor on an exciting round-tour of the history of this traditional club, established in 1887. Factual information and the emotional highpoints of the club's history are to be conveyed with the assistance of the exhibition's design.

Le musée du football dans le stade de l'AOL emmène les visiteurs dans une promenade captivante à travers l'histoire de ce club bien établi, fondé en 1887. Le design de l'exposition a pour but de transmettre des informations factuelles mais aussi les points forts émotionnels de l'histoire du club.

El museo del estadio de AOL conduce a los visitantes a un interesante paseo por la historia de este club fundado en 1887. Con la ayuda del diseño de la exposición se quiere transmitir tanto la información objetiva como los momentos cumbre de la historia de este club.

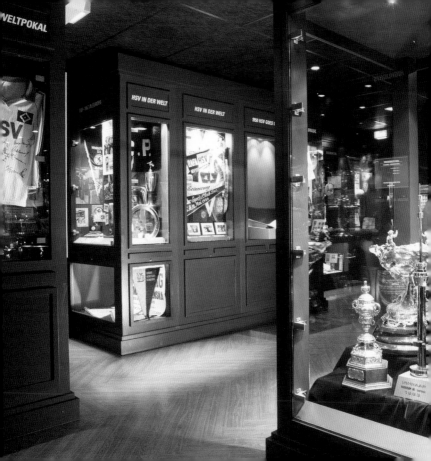

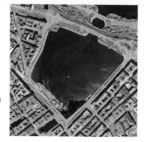

Jungfernstieg

WES & Partner Landschaftsarchitekten
André Poitiers Architekt

2005
Jungfernstieg
Innenstadt

www.lebendiger-jungfernstieg.de
www.wesup.de

Der Jungfernstieg soll künftig wieder zu einem großzügigen, zusammenhängenden Stadtraum werden, der zum Flanieren und Erholen einlädt. Das wichtigste Element der Neugestaltung ist eine lang gestreckte, tribünenartige Treppenanlage. Ein kubischer Pavillonbau setzt einen markanten Schwerpunkt in der Gesamtanlage.

In future, the Jungfernstieg is once again set to become a spacious, interconnected city zone, which invites you to take a stroll and relax. The most important element of the new design is a long stretch of stairway facilities that resemble a spectator's gallery. A cubic pavilion structure creates a distinctive focal point for the entire site.

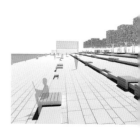

A l'avenir, le Jungfernstieg doit redevenir un espace urbain généreux et cohérent invitant à la flânerie et la détente. L'élément le plus important de ce remodelage est une série d'escaliers étirés en longueur et ressemblant à une tribune. L'accent fort dans ce complexe : un pavillon cubique bien placé.

En el futuro, el Jungfernstieg debe convertirse nuevamente en un espacio urbano amplio y unitario que invite a pasear y a descansar. El elemento más importante del nuevo diseño es una escalinata alargada y similar a una tribuna. Un pabellón cúbico actúa como marcado centro de gravedad de toda la instalación.

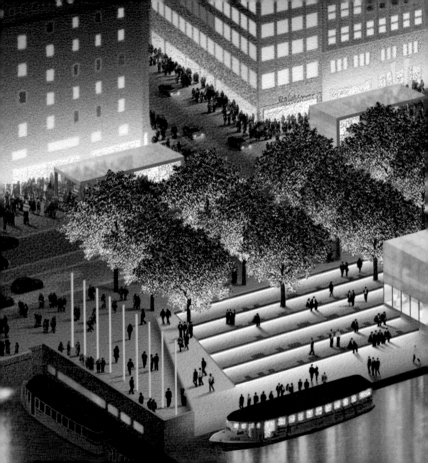

ZOB Zentraler Omnibusbahnhof
Central Bus Station

ASW Architekten Silcher Werner + Redante

2003
Adenauerallee 78
St. Georg

Weithin sichtbares Markenzeichen des Zentralen Omnibusbahnhofs ist das 11 m hohe und rund 2.800 m² große, sichelförmige Glasdach. Darunter befinden sich die Bussteige sowie ein Kiosk, zwei Restaurants und mehrere Reisebüros als Serviceangebot für die Reisenden.

By far the most visible sign of the Central Bus Station is the 11 m high and around 2,800 m² crescent-shaped glass roof. The bus stops are located beneath, as well as a kiosk, two restaurants and several travel agencies, which are provided as a service for travelers.

L'emblème bien visible tout alentour de la gare routière centrale est un toit de verre en forme de croissant de 11 m de haut et de 2 800 m². En dessous se trouvent les quais des bus, un kiosque, deux restaurants et plusieurs agences de voyage pour le service aux voyageurs.

Esta cubierta de cristal con forma de hoz, de 11 m de altura y con una superficie entorno a los 2.800 m², sigue siendo el emblema de la estación central de autobuses. Debajo de ella están situados los andenes de los autobuses y las instalaciones de servicio para los clientes, como un quiosco, dos restaurantes y varias agencias de viajes.

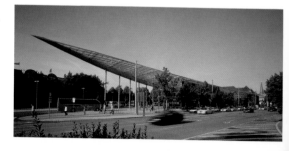

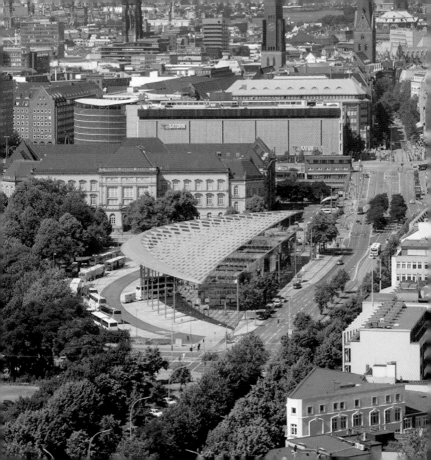

HafenCity InfoCenter
HarborCity InfoCenter

Studio Andreas Heller GmbH
gmp – Architekten von Gerkan, Marg und Partner

2000
Am Sandtorkai 30
HafenCity

www.hafencity.com
www.studio-andreas-heller.de
www.gmp-architekten.de

Ein ehemaliges Kesselhaus dient als Informationszentrum für die Entwicklung der HafenCity, einem der derzeit wichtigsten Stadtplanungsprojekte in Europa. Im Mittelpunkt steht das eindrucksvolle Gesamtmodell, das um Bild- und Projektionsflächen sowie mehrere Info-Pulte ergänzt wird.

A former boiler-house serves as an information center for the development of HarborCity, currently one of the most important urban planning projects in Europe. The impressive, complete model stands at the center, being complemented by a screen and projection area as well as several info desks.

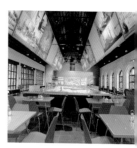

Une ancienne chaufferie fait fonction de centre d'informations sur le développement de la HafenCity, l'un des projets urbanistiques actuellement les plus importants d'Europe. Au centre, se tient l'impressionnante maquette générale flanquée de plusieurs consoles d'information et de surfaces de projections et d'images.

Un antiguo edificio de calderas sirve hoy como centro de información para el desarrollo de la HafenCity y, actualmente, es uno de los proyectos urbanísticos más importantes de Europa. En el centro aparece el impresionante modelo completo que se completa con pantallas de imágenes y de proyección además de varios atriles informativos.

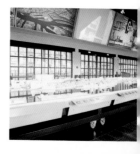

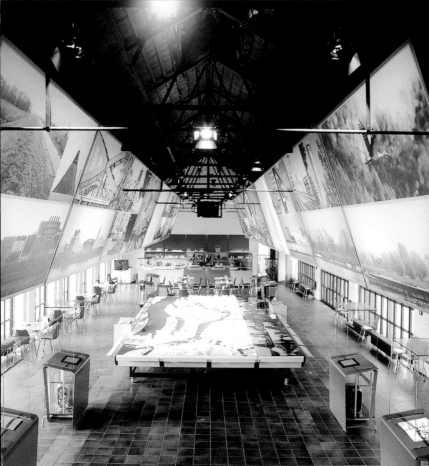

Kibbelsteg Brücke
Kibbelsteg Bridge

gmp – Architekten von Gerkan, Marg und Partner

2002
Kibbelsteg
HafenCity

www.gmp-architekten.de

Drei über je zwei Stege miteinander verbundene Bogenbrücken bilden zusammen die insgesamt 220 m lange Brückenanlage. Der untere Steg ermöglicht Fußgängern und Radfahrern den wettergeschützten Zugang zur HafenCity, der obere Steg dient bei extremem Hochwasser als Zufahrt für Feuerwehr, Polizei und Sanitätsfahrzeuge.

Three arched bridges that are each connected to each other by two walkways form the bridge facility, measuring a total of 220 m long. The lower walkway gives pedestrians and cyclists weatherproof access to HarborCity, while the upper walkway functions at extreme high tide as an access point for fire, police and paramedics' vehicles.

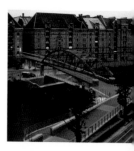

Trois ponts en arc reliés entre eux par respectivement deux passerelles constituent ensemble cette installation de 220 m de long. La passerelle inférieure permet aux piétons et cyclistes d'accéder à la HafenCity protégés des intempéries et la passerelle supérieure est une voie d'accès pour les voitures de police, pompiers et ambulances en cas de crue extrême.

Tres arcadas unidas entre sí por dos pasarelas forman una construcción de una longitud total de 220 m de largo. La pasarela inferior permite a los transeúntes y ciclistas dirigirse a la HafenCity protegidos de las inclemencias, mientras que la superior actúa como vía de acceso para los bomberos, la policía y las ambulancias en caso de inundaciones.

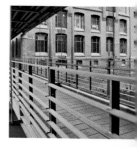

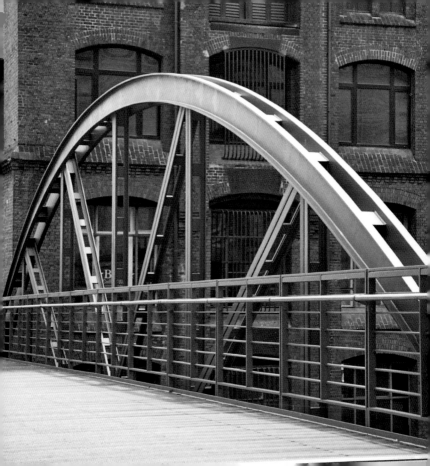

View Point

renner hainke wirth architekten
WTM Windels Timm Morgen

2004
Kibbelsteg
HafenCity

www.hafencity.com
www.rhw-architekten.de
www.wtm-ingenieure.de

Der Turm direkt neben dem Kreuzfahrtterminal ist ein auffallender Orientierungs- und Aussichtspunkt im Entwicklungsgebiet der HafenCity. Die Stahlkonstruktion ist mit orangefarbenen Blechen verkleidet, in die auf der Ebene der Aussichtsplattform unregelmäßige Öffnungen eingeschnitten sind.

The tower directly next to the cruise ship terminal is a striking orientation and viewing point in the development zone of HarborCity. The steel construction is clad with orange-colored metal plates, into which irregular openings are cut at the level of the viewing platform.

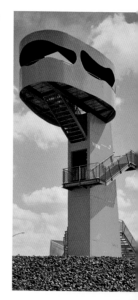

La tour située directement à côté du terminal de croisières est un point de vue et d'orientation très frappant dans la zone de développement de la HafenCity. La construction métallique est habillée de tôles orange dans lesquelles sont découpées des ouvertures irrégulières au niveau de la plate-forme panoramique.

Esta torre situada justo al lado de la terminal de cruceros es un llamativo punto de orientación además de un mirador en la zona en desarrollo de la HafenCity. Esta construcción de acero está revestida con planchas de metal de color naranja en las que se han practicado cortes irregulares a la altura de la plataforma.

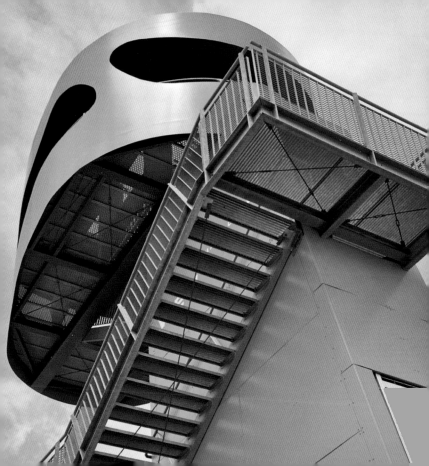

HCC Hamburg Cruise Center

renner hainke wirth architekten
Werner Sobek Ingenieure

2004
Am Grasbrookhafen 11
HafenCity

www.hafencity.com
www.rhw-architekten.de
www.wsi-stuttgart.de

Der Bau des temporären Kreuzfahrtterminals in der HafenCity gelang mit einfachen Mitteln, die aber einen starken Bezug zur Umgebung haben: Zwei Reihen von übereinander stehenden Containern und zwei Glasfronten bilden die Seitenwände des Terminals, darüber liegt ein leichtes, über einen Fachwerkträger gespanntes Membrandach.

The building of a temporary cruise ship terminal in HarborCity succeeded with simple resources, which bear a strong relationship to the surroundings: the terminal's side walls are formed by three rows of containers standing on top of each other, with an entire wall as a glass front. A light roof, stretched across support beams, rests on top of this structure.

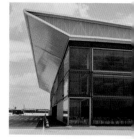

La construction du terminal de croisière temporaire dans la HafenCity s'est faite par des moyens très simples en rapport étroit avec le voisinage : trois rangées de conteneurs superposés et une façades vitrées constituent les parois latérales du terminal ; au-dessus, une toiture légère à membrane est soutenue par une poutre en treillis.

La construcción de esta terminal provisional de cruceros en la HafenCity se realizó utilizando materiales sencillos que poseen, sin embargo, una fuerte relación con el entorno: tres filas superpuestas de contenedores y un frente de cristal conforman las paredes laterales de esta Terminal y, por encima, se extiende una cubierta de membrana tensada sobre una celosía reticulada.

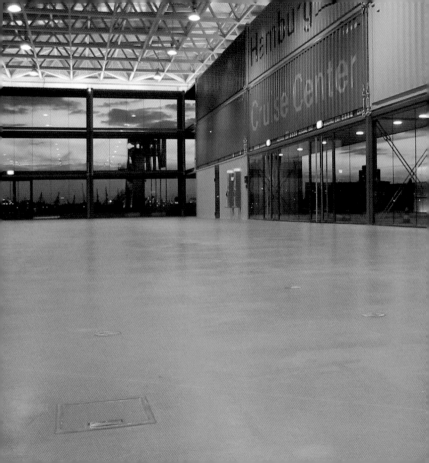

Neue Messe Hamburg
New Trade Fair

Ingenhoven und Partner Architekten

2008
Karolinenstraße
Rotherbaum

www.hamburg-messe.de
www.ingenhovenundpartner.de

Das innerstädtische Messegelände soll sich harmonisch in den Kontext des umgebenden Stadtraumes integrieren. Die neuen Hallen präsentieren sich als große „Schaufenster" zur Stadt, eine so genannte Messe-Loggia verknüpft als zentrale Verbindungsachse die verschiedenen Messebereiche.

The inner-city exhibition site is meant to integrate harmoniously with the context of the surrounding city area. The new halls are presented to the city as large "showcase windows", a so-called exhibition loggia acting as the central integration axis connects the different exhibition areas.

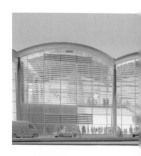

Le nouveau parc des expositions à l'intérieur de la ville doit s'intégrer harmonieusement dans l'espace urbain environnant. Les nouveaux halls jouent le rôle de grandes « vitrines » sur la ville, tandis qu'un axe de liaison appelé loggia de l'exposition relie les différentes parties du champ de foire.

El recinto ferial situado en el casco urbano debe integrarse de forma armoniosa en el espacio urbano circundante. Los nuevos pabellones se presentan como grandes "escaparates" orientados hacia la ciudad y una especie de galería actúa como eje central de unión entre las diferentes áreas de la feria.

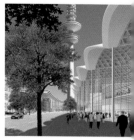

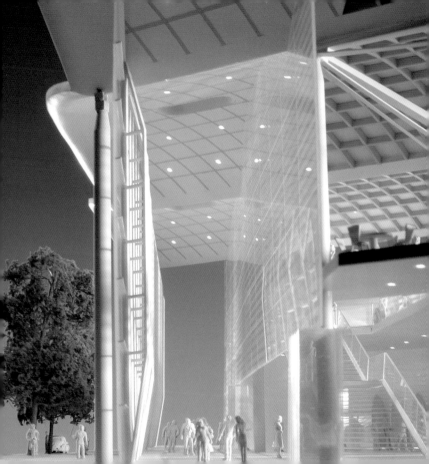

Polizeirevier Davidwache
Police Station

Prof. Bernhard Winking Architekten BDA

2004
Spielbudenplatz 31
St. Pauli

www.winking.de

Ein selbstbewusster Erweiterungsbau ergänzt die wohl bekannteste Polizeiwache Deutschlands, ohne dass der Ursprungsbau von Fritz Schumacher dadurch an Prägnanz und Eigenständigkeit verlieren würde. Die formale Gestaltung und die Orientierung des Neubaus greifen die Besonderheiten des Eckgrundstücks auf.

A self-assured extension complements what is probably one of Germany's most well known police stations, but without the original building by Fritz Schumacher losing its influence and unique character. The formal design and orientation of the new building adopt special features of the corner site.

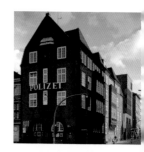

L'extension du poste de police sans aucun doute le plus connu d'Allemagne est une construction pleine d'assurance. Pour autant, le bâtiment d'origine de Fritz Schumacher ne perd rien de sa prestance et de son autonomie. La conception formelle et l'orientation de l'extension reprennent les particularités du terrain à l'angle d'une rue.

Un soberbio edificio anexo completa la comisaría más conocida de Alemania sin que ello suponga una pérdida del carácter y la autonomía de la construcción original de Fritz Schumacher. La estructuración formal y la orientación del nuevo edificio recogen las particularidades del anguloso solar.

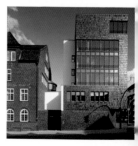

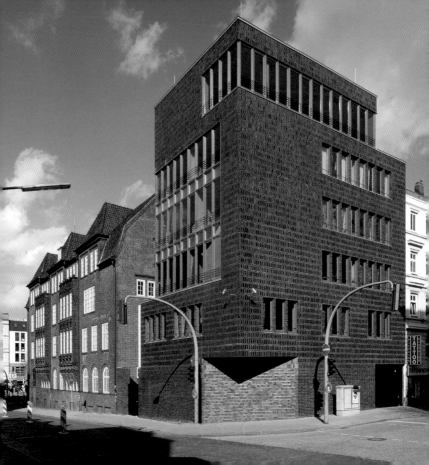

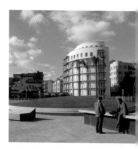

Antoni-Park

arbos Landschaftsarchitekten Greis Klöster

2005
Antoni-Straße /
Bernhard-Nocht-Straße
St. Pauli

www.parkfiction.org

Auf Basis einer Bürgerinitiative entstand dieser Park mit Blick auf die Elbe. Seiner Gestaltung liegt kein abstrakt-architektonisches Konzept zu Grunde, vielmehr wurden hier individuelle Wünsche und Ideen der Anwohner umgesetzt.

This park with a view of the river Elbe was created on the basis of a citizens' initiative. There is no abstract, architectural design underpinning its structure. Rather, here individual wishes and residents' ideas were put into practice.

Ce parc avec vue sur l'Elbe est né d'une initiative citoyenne. Sa conception ne repose pas sur un concept architectural abstrait mais traduit plutôt les désirs et les idées individuelles des riverains.

Este parque con vistas al Elba fue creado por iniciativa ciudadana. Su diseño no se basa en un abstracto concepto arquitectónico sino en los deseos y las ideas individuales de los vecinos.

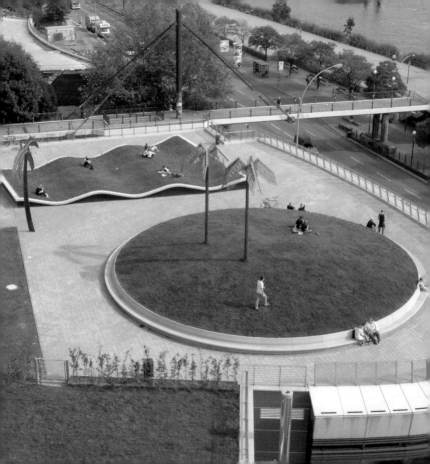

Orang Utan Haus
Tierpark Hagenbeck
Orangutan House Hagenbeck Zoo

Architekten Ingenieure PSP
Wetzel & von Seht Ingenieurbüro für Bauwesen

2004
Lokstedter Grenzstraße 2
Stellingen

www.hagenbeck.de
www.psp-architekten.de
www.wetzelvonseht.com

Eine Kuppel mit einem Durchmesser von 32 m überdacht das Orang-Utan-Haus im Tiergarten Hagenbeck. Die stählernen Rippen der Kuppel sind mit transparenten, luftgefüllten Membrankissen ausgefacht. Der Clou der Konstruktion: Durch Übereinanderschieben der zwei Kuppelteile kann das Dach zur Hälfte geöffnet werden.

A dome with a diameter of 32 m forms the roof of the orangutan house in Hagenbeck Zoo. The steel ribs of the dome are equipped with transparent, air-filled membrane cushions. The key to the construction: the roof can be half-opened by moving the two parts of the dome over each other.

Une coupole de 32 m de diamètre couvre la maison des orangs-outans du jardin zoologique Hagenbeck. Les côtes d'acier de la coupole sont garnies de coussins en membrane transparents remplis d'air. Le clou de la construction : le toit s'ouvre à moitié quand l'une des deux parties de la coupole coulisse sur l'autre.

Una cúpula con un diámetro de 32 metros techa la Orang-Utan-Haus en el parque zoológico de Hagenbeck. Los nervios de acero de la cúpula están mampos-teados con cojines de membranas transparentes y llenos de aire. Lo sofisticado de la construcción: la posibilidad de deslizar una parte de la cúpula sobre la otra permite abrir la mitad del techo.

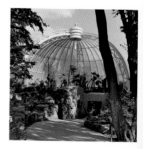

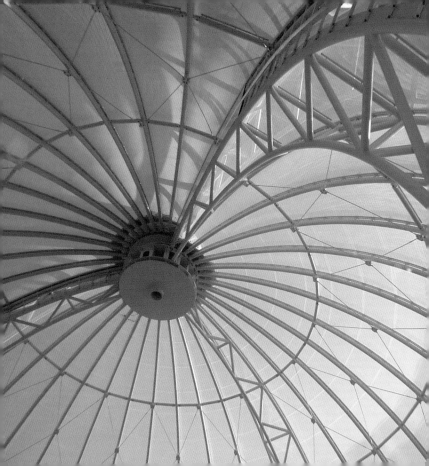

to stay . hotels

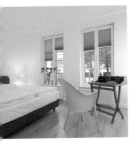
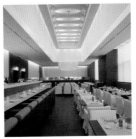
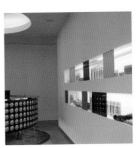
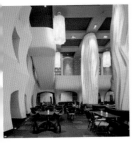
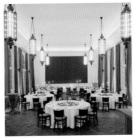
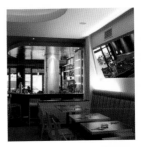

93

Dorint am alten Wall

k/h Büro für Innenarchitektur Klein Haller

2000
Am alten Wall 40
Innenstadt

www.dorint.de
www.klein-haller.de

Das Hotel liegt an einem ruhigen Alsterfleet im Herzen der Stadt und hat sogar einen eigenen Bootsanleger zu bieten. Das ausgesprochen moderne Design verleiht den fast 250 Zimmern und Suiten ein exklusives Ambiente.

The hotel is located on a peaceful Alsterfleet in the heart of the city and even offers boats a private mooring point. The emphatically modern design gives an exclusive ambiance to the almost 250 rooms and suites.

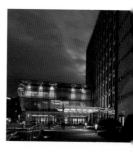

L'hôtel se situe au bord d'un Alsterfleet tranquille au cœur de la ville et propose même son propre embarcadère. Le design réellement moderne confère aux quelque 250 chambres et suites une atmosphère exclusive.

El hotel está ubicado en un tranquilo Alsterfleet, en el corazón de la ciudad, y posee incluso un atracadero propio. Su diseño extraordinariamente moderno dota a las 250 habitaciones de un ambiente exclusivo.

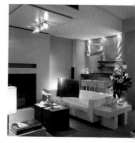

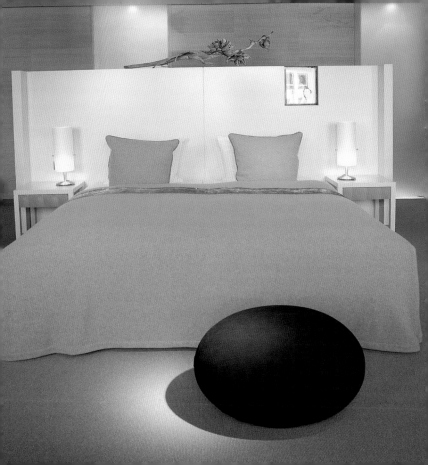

SIDE Hotel

Jan Störmer Partner
matteo thun
WTM Windels Timm Morgen

2001
Drehbahn 49
Innenstadt

www.side-hotel.de
www.stoermer-partner.de
www.matteothun.com
www.wtm-ingenieure.de

Das SIDE Hotel ist ein Gesamt-kunstwerk: Architekten und In-nenarchitekten arbeiteten eng zusammen, um das durchgängi-ge Designkonzept konsequent umzusetzen. Für das fast 30 m hohe Atrium des Gebäudes schuf der Regisseur Robert Wil-son eine spektakuläre Lichtin-szenierung.

The SIDE hotel is a complete work of art: architects and inte-rior designers worked closely together to put the continuous design concept in practice throughout. Robert Wilson, the director, created a spectacular light installation for the building's almost 30 m high atrium.

L'hôtel SIDE est une œuvre d'art en soi: architectes et décora-teurs ont travaillé en étroite col-laboration pour décliner le con-cept de design de façon cohé-rente à tous les niveaux. Pour l'atrium de presque 30 m de haut le réalisateur Robert Wilson a créé une mise en scène specta-culaire de l'éclairage.

El hotel SIDE es en sí una obra de arte. Los arquitectos y los interioristas cooperaron estre-chamente para plasmar a la práctica de forma consecuente este concepto universal de dise-ño. El director Robert Wilson creó una espectacular escenifi-cación luminosa para el atrio del edificio, de casi 30 m de altura.

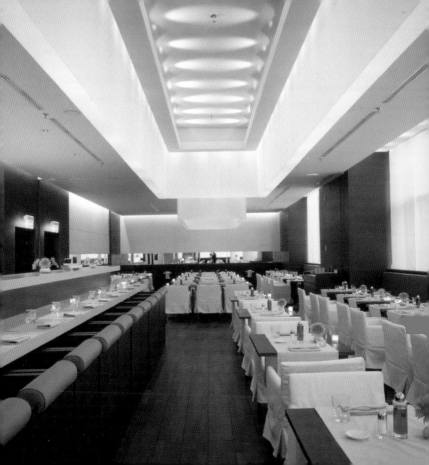

Le Royal Meridien

Kleffel Köhnholdt Papay Warncke Architekten

2003
An der Alster 52-56
St. Georg

www.lemeridien.com
www.kkpw.de

Schmale, wellenförmige Gesimse zwischen jedem Geschoss prägen die Fassade des Royal Meridien. Jeweils vor den Zimmern erweitern sich diese Vorsprünge zu Balkonen. In der überhöhten Dachzone liegen hinter einer geneigten Glasfassade das Restaurant und die Suiten mit einem grandiosen Blick über die Außenalster.

Narrow, wave-like sills between every floor influence the Royal Meridien's façade. These projections each extend to balconies in front of the guest rooms. In the raised roof area, the restaurant and suites are located behind a sloping, glass façade and they offer a splendid view across the outer Alster.

D'étroites corniches ondoyantes entre chaque étage caractérisent la façade du Royal Méridien. Au niveau des chambres les ondes s'élargissent et forment des balcons. Dans la partie surélevée, derrière une façade de verre inclinée, sont installés le restaurant et les suites avec une vue grandiose sur l'Außenalster.

Las estrechas y onduladas molduras situadas entre los pisos caracterizan la fachada del Royal Meridien. Estos voladizos e extienden delante de cada habitación convirtiéndose en balcones. En la zona sobreelevada de la azotea, detrás de una fachada de cristal inclinada, se encuentran el restaurante y las suites, con una impresionante vista sobre el Außenalster.

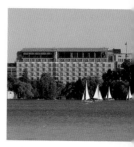

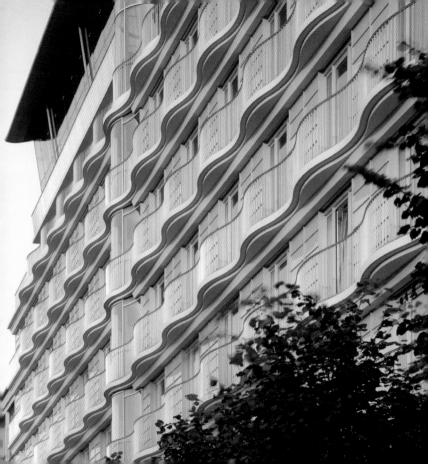

Dorint Novotel an der Alster

JOI-Design GmbH

2004
Lübecker Straße 3-11
Hohenfelde

www.dorint.de
www.joi-design.com

Mit seiner ausgesprochen hellen und frischen Farbgebung strahlt das Dorint Novotel auch bei schlechtem Wetter eine freundliche Atmosphäre aus. Eine besondere Herausforderung für die Architekten lag in der Gliederung des lang gestreckten Baukörpers in einzelne, wohlproportionierte Raumzonen.

The Dorint Novotel radiates a friendly atmosphere even during bad weather because of its decidedly bright and fresh color scheme. A particular challenge for the architects was the design of the long expanse of the building into single, well-proportioned room zones.

Avec ses couleurs vraiment claires et fraîches le Dorint Novotel dégage une atmosphère sympathique, même par mauvais temps. Le défi qu'ont dû relever les architectes était de structurer ce corps de bâtiment tout en longueur en espaces séparés bien proportionnés.

El colorido marcadamente claro y fresco del Dorint Novotel hace que el hotel emane una agradable atmósfera incluso con mal tiempo. El mayor reto para los arquitectos fue estructurar este cuerpo alargado en espacios individuales y bien proporcionados.

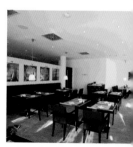

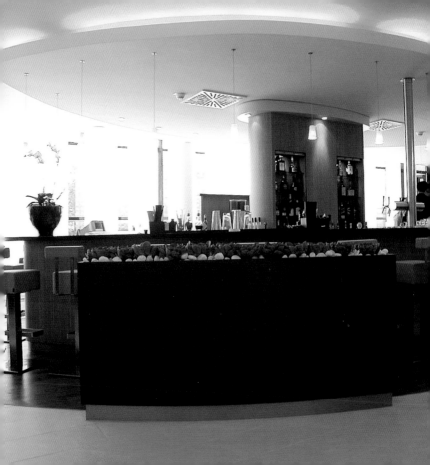

Junges Hotel

Architekten v. Bassewitz Limbrook Partner

2000
Kurt-Schumacher-Allee 14
St. Georg

www.jungeshotel.de
www.architekten-blp.de

Nicht Naturstein oder Putz, sondern Panele aus gewelltem Aluminium und farbige Glasscheiben prägen den Bau, der sich – wie der Name schon sagt – an junge, unkonventionelle Reisende wendet. Formal besteht das Hotel aus zwei neungeschossigen Türmen, die durch einen viergeschossigen Zwischenbau verbunden sind.

Not natural stone or plaster, but panels made of corrugated aluminum and colorful glass panes influence the building, which—as the name already suggests—appeals to young, unconventional travelers. Formally, the hotel is comprised of two, nine-storey towers, which are connected by a four-storey intervening building.

Ici pas de pierre naturelle ou de crépi, mais des panneaux d'aluminium ondulés et des vitres colorées pour caractériser cet édifice qui s'adresse, comme son nom l'indique, à de jeunes voyageurs peu conventionnels. Formellement l'hôtel est constitué de deux tours de neuf étages reliées par un bâtiment intermédiaire de quatre étages.

Esta edificación se caracteriza por sus paneles de aluminio ondulado y sus coloridas placas de cristal. Como su propio nombre indica (hotel joven), este hotel está pensado para viajeros jóvenes y poco convencionales. Desde el aspecto formal, el hotel se compone de dos torres de nueve pisos unidas por una edificación intermedia de cuatro plantas.

Mercure an der Messe

BRT Architekten Bothe Richter Teherani

2002
Schröderstiftstraße 3
Rotherbaum

www.mercure.com
www.brt.de

Ein winkelförmiger Baukörper mit eigenartig „gescheckter" Fassade schließt die Blockbebauung an der Schröderstiftstraße. Der zehngeschossige Eckturm wirkt als neue städtebauliche Dominante innerhalb des Stadtbildes. Im Bar- und Restaurantbereich herrscht eine kühle, von Lichtinszenierungen geprägte Atmosphäre vor.

An angular building with a unique, "chequered" façade finishes off the boundary estate building on the Schröderstiftstraße. The tenstorey, corner tower appears as a new urban feature dominating the city skyline. In the bar and restaurant area, a cool atmosphere predominates and is influenced by light installations.

Un immeuble en équerre avec une façade singulièrement tachetée parachève la construction par bloc sur la Schröderstiftstraße. Cette tour en coin de dix étages est une des nouvelles dominantes parmi les réalisations urbanistiques au sein de la ville. Dans la partie bar et restaurant règne une atmosphère froide marquée par la mise en scène des éclairages.

Un edificio anguloso con una inusual fachada dividida en áreas de diferentes colores, cierra esta edificación en bloque en la Schröderstiftstraße. La torre de esquina es el nuevo elemento urbanístico dominante en la ciudad. En la zona del bar y el restaurante predomina una atmósfera fría caracterizada por la decoración luminosa.

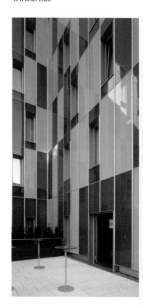

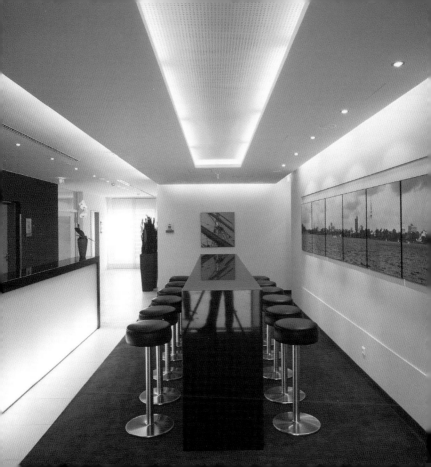

East

Jordan Mozer and Associates, Ltd.

2004
Simon-von-Utrecht-Straße 31
St. Pauli

www.east-hamburg.de
www.mozer.com

Fernöstliche, europäische und amerikanische Inspirationsquellen vereinen sich in diesem Hotel zu einem außergewöhnlichen Architekturkonzept. Ein altes Gießereigebäude wurde hierzu komplett umgebaut und erweitert. Kulissenhafte Einbauten aus weißem Gips stehen in reizvollem Kontrast zu dem Ziegelmauerwerk des historischen Industriebaus.

In this hotel, Far Eastern, European and American sources of inspiration unite to an extraordinary architectural concept. An old foundry was completely remodeled and extended for this purpose. Staged installations made of white plaster are a charming contrast to the brickwork of the historic, industrial building.

Les sources d'inspiration extrême-orientales, européennes et américaines combinées dans cet hôtel débouchent sur un concept architectural exceptionnel. L'ancien bâtiment d'une fonderie a été entièrement transformé et agrandi. Des encastrements de plâtre blanc en arrière plan contrastent agréablement avec les murs de brique du bâtiment industriel historique.

Fuentes de inspiración del Extremo Oriente, Europa y América se fusionan en este hotel convirtiéndose en un extraordinario concepto arquitectónico. Para ello se reformó y amplió una vieja fábrica de fundición. Elementos añadidos propios de un escenario y elaborados con yeso blanco, establecen un interesante contraste con los muros de mampostería de ladrillo de la antigua construcción industrial.

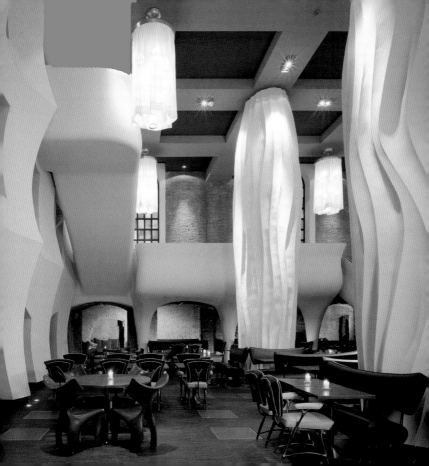

Monopol

JOI-Design GmbH

2005
Reeperbahn 48-52
St. Pauli

www.joi-design.com
www.monopol-hamburg.de

Das Monopol mitten auf der Reeperbahn gilt als traditionelles „Künstlerhotel" mit ganz speziellem Ambiente. Inzwischen wurden die Bar und das Restaurant im Erdgeschoss jedoch aufwändig umgestaltet. Das neue Interieur soll sowohl das bisherige Publikum als auch neue Gäste ansprechen.

The Monopol, situated in the middle of the Reeperbahn, is regarded as a traditional "artists' hotel" with a quite special ambiance. But meanwhile, the bar and restaurant on the ground floor were painstakingly remodeled. The new interior is supposed to conform both to the former clientele as well as suiting the new guests.

Le Monopol au milieu de la Reeperbahn passe pour être un « hôtel d'artistes » traditionnel avec une ambiance très particulière. Entre-temps, le bar et le restaurant du rez-de-chaussée ont été redessinés à grands frais. Le nouvel intérieur doit plaire tant au public habituel qu'aux nouveaux hôtes.

El Monopol, situado en pleno Reeperbahn, está considerado como un tradicional "hotel de artistas" con un ambiente muy especial. Actualmente tanto el bar como el restaurante de la planta baja han experimentado una completa reforma. El nuevo interior pretende llegar al antiguo público pero también a nuevos clientes.

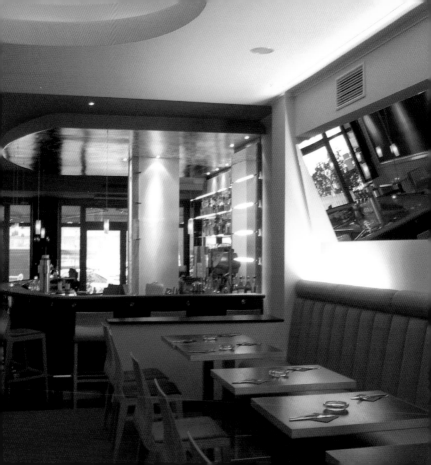

Schlaflounge

Kathrin Dera-Hahne

2004
Vereinsstraße 545
Eimsbüttel

www.schlaflounge.de

In einem Jugendstilgebäude in unmittelbarer Nähe zum Schanzenviertel finden sich in der Schlaflounge fünf moderne, geschmackvoll eingerichtete Zimmer. Damit bietet das Haus eine ganz besondere und individuelle Alternative zu einem „normalen" Hotelbetrieb.

In a Jugendstil building in the immediate vicinity of the Schanzen district, five modern, tastefully designed rooms are located in the Schlaflounge. This enables the hotel to offer a quite special and unique alternative to conventional hotel accommodation.

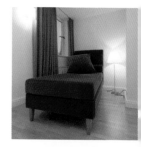

Dans un bâtiment de style Art Nouveau à proximité immédiate du Schanzenviertel, il y a dans le Schlaflounge cinq chambres modernes aménagées avec beaucoup de goût. Cet établissement propose ainsi une alternative individuelle et spéciale à l'hôtellerie « normale ».

En el Schlaflounge, un edificio de estilo modernista situado muy cerca del barrio Schanzen, encontramos cinco habitaciones modernas y decoradas con un exquisito gusto. De esta forma la casa ofrece una alternativa muy especial e individual al alojamiento en un hotel "normal".

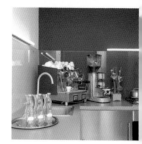

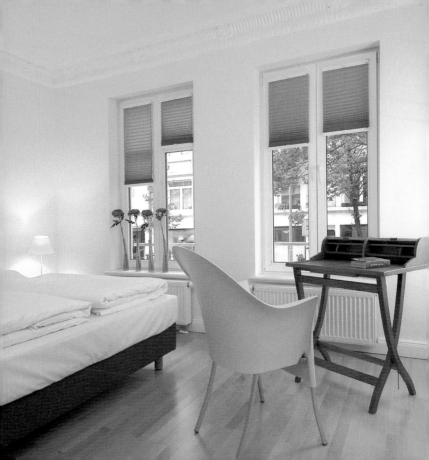

YoHo

atelier centrale Bettina Hermann Dirk Danielsen

2000
Moorkamp 5
Eimsbüttel

www.yoho-hamburg.de
www.atelier-centrale.de

Hotel und Restaurant sollen als integrativer Ort für verschiedene Kulturen, Altersgruppen und soziale Schichten dienen. Dieser hohe soziale Anspruch findet in einem schlichten, klaren Design mit einem gleichberechtigten Nebeneinander von Alt und Neu seine Entsprechung.

The hotel and restaurant are to serve as an integrative location for different cultures, age groups and social classes. This high, social standard is matched by a simple, clear design with an equal partnership of old and new.

L'hôtel et le restaurant se veulent le lieu d'intégration de cultures, classes sociales et groupes d'âge différents. Cette exigence sociale extrême débouche sur un design simple et pur où cohabitent à égalité l'ancien et le nouveau.

El hotel y el restaurante deben servir como lugar integrador de diferentes culturas, edades y capas sociales. Esta elevada pretensión social encuentra su analogía en el diseño claro y sencillo donde conviven, con igualdad de derechos, lo viejo y lo nuevo.

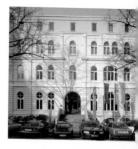

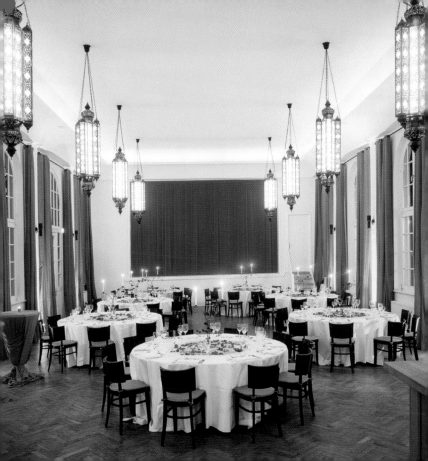

25hours

3meta märklstetter + fischer
Thomas Lau + Mark Hendrik Blieffert

2003
Paul-Dessau-Straße 2
Altona

www.25hours-hotel.com
www.3meta.de

Zurück in die Zukunft: Wie aus einem Sciencefictionfilm der 60er Jahre wirkt die Inneneinrichtung dieses Hotels. Tatsächlich wurden die meisten Möbel speziell für das 25hours entworfen. Ergänzt um einige Design-Klassiker sorgen sie für ein außergewöhnliches und stilvolles Interieur.

Back to the Future: The interior of this hotel is like a 1960s science fiction film. In fact, most of the furniture was designed especially for the 25hours. Supplemented by a few design classics, they ensure an extraordinary and stylish interior.

Retour dans le futur: l'aménagement intérieur de cet hôtel fait penser à un film de science-fiction des années 60. La plupart des meubles ont effectivement été dessinés spécialement pour le 25hours. Complétés par quelques classiques du design ils rendent l'intérieur exceptionnel et très stylisé.

Vuelta al futuro: La decoración del interior de este hotel recuerda a una película de ciencia ficción de la década de 1960. De hecho, la mayoría de los muebles fueron especialmente diseñados para el 25hours. Complementado con algunas piezas clásicas de diseño, este mobiliario hace del interior un lugar único y lleno de estilo.

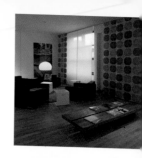

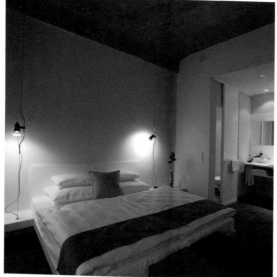

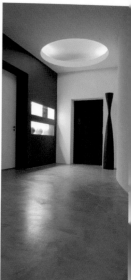

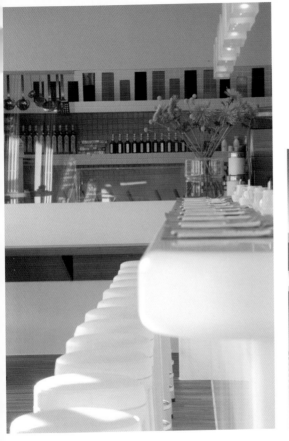

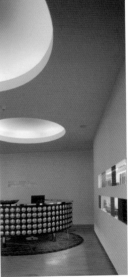

Gastwerk

Lange, Vogler & Partner

2000
Beim Alten Gaswerk 3 /
Daimlerstraße
Ottensen

www.gastwerk-hotel.de

Das alte Gaswerk bescherte dem Westen Hamburgs erstmals Licht in Straßen und Häusern. Mittlerweile hat sich das imposante Industriedenkmal in Hamburgs erstes Design-Hotel verwandelt, in dem sich historische Architektur und aktuelles Design auf überraschende und harmonische Weise verbinden.

The old gas works first provided light on the streets and in the houses to the west of Hamburg. Meanwhile, the imposing, industrial monument has been transformed into Hamburg's first design hotel, where historic architecture and contemporary design are integrated in a surprising and harmonious way.

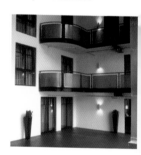

L'ancienne usine à gaz apporta d'abord la lumière aux rues et maisons de l'ouest de Hambourg. Depuis, cet imposant monument industriel est devenu le premier hôtel de design de Hambourg dans lequel architecture historique et design contemporain sont associés de manière surprenante et harmonieuse.

La antigua central de gas fue la primera en proporcionar luz a las calles y las casas del oeste de Hamburgo. En la actualidad, este impresionante monumento industrial se ha convertido en el primer hotel de diseño de la ciudad, y en él la arquitectura histórica se une de una forma sorprendente y armoniosa con el diseño moderno.

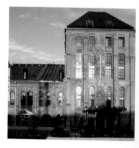

118

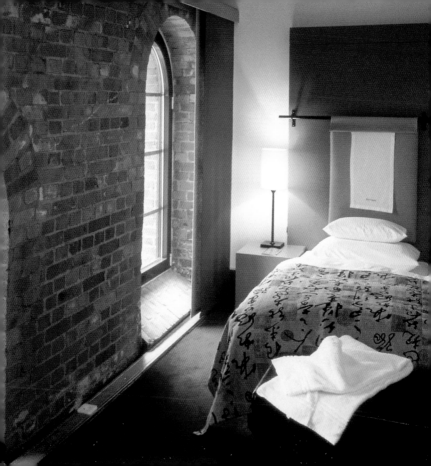

to go . eating
drinking
clubbing
leisure
wellness, beauty & sport

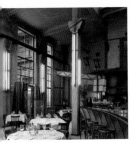
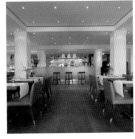
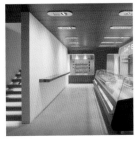
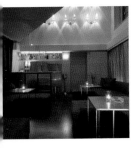
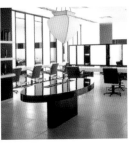
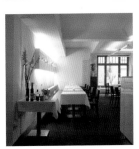
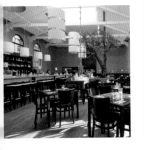
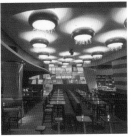
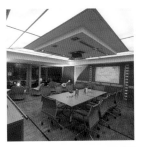

Brook

Droppelmann, Ratke

2002
Bei den Mühren 98
Innenstadt

www.restaurant-brook.de

Der großzügige, nahezu quadratische Innenraum des Brook-Restaurants bietet aus fünf Panoramafenstern einen beeindruckenden Blick auf die alte Hafen- und Lagerhauskulisse der Speicherstadt.

The generous, almost square interior of Brook Restaurant offers an impressive view out of five panoramic windows of the old harbor and storehouse scenery in the Speicherstadt.

La très spacieuse salle presque carrée du restaurant Brook offre à travers cinq fenêtres panoramiques une vue impressionnante sur le quartier du vieux port et des entrepôts de la Speicherstadt en arrière plan.

Las cinco ventanas panorámicas del restaurante Brook, con un espacio interior amplio y casi cuadrado, ofrecen una impresionante vista sobre el puerto y los almacenes de la Speicherstadt.

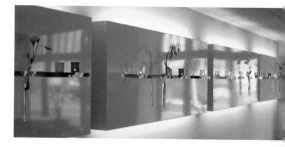

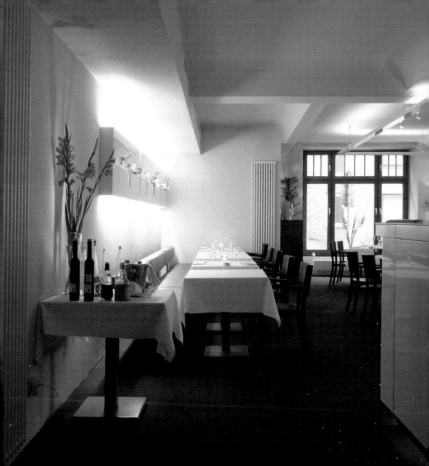

Pavillon am Binnenhafen
Pavilion at the Inner Harbor

Akyol Gullotta Kamps Architekten
gmp – Architekten von Gerkan, Marg und Partner

2002
Kehrwieder 9a
HafenCity

www.agk-architects.com
www.gmp-architekten.de

Als klassische italienische Bar ergänzt der Pavillon die Bürobauten des Hanseatic Trade Center an der Kehrwiederspitze. Materialien wie Platanenholz, Blattgold, Naturstein und Edelstahl schaffen ein elegantes, mediterranes Ambiente.

In the style of a classic Italian bar, the Pavilion complements the office buildings of the Hanseatic Trade Center at the Kehrwiederspitze. Materials such as plane-tree wood, gold leaf, natural stone and stainless steel create an elegant, Mediterranean ambiance.

Le Pavillon aménagé en bar italien classique complète les immeubles de bureaux du Hanseatic Trade Center sur la Kehrwiederspitze. Des matériaux tels que du bois de platane, de l'or en feuille, de la pierre naturelle et de l'acier créent une ambiance méditerranéenne élégante.

El Pavillon, un clásico bar italiano, complementa los edificios de oficinas del Hanseatic Trade Center, en la Kehrwiederspitze. Materiales como la madera de platanero, el pan de oro, la piedra natural y el acero inoxidable crean un ambiente elegante y mediterráneo.

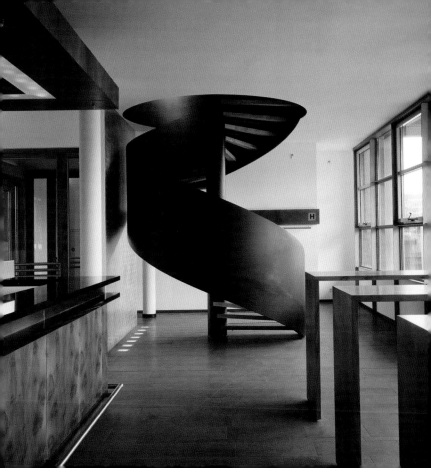

Dat Backhus

André Poitiers Architekt
Wetzel & von Seht Ingenieurbüro für Bauwesen

2002
Jungfernstieg 45
Innenstadt

www.wetzelvonseht.com

Eine Bäckerei mit einem völlig neuen Image: Dat Backhus überrascht mit einem hypermodern gestalteten Verkaufsraum sowie einem schicken, loungeartigen Café im Obergeschoss.

A bakery, with a totally new image: Dat Backhus is surprising for the hyper-modern design of the sales floor as well as a stylish, lounge-type café on the upper floor.

Une boulangerie d'un style complètement nouveau : Dat Backhus crée la surprise avec un magasin de vente à l'aménagement hypermoderne et un café très chic type salon au premier étage.

Una panadería con una imagen completamente nueva: Dat Backhus sorprende con el diseño hipermoderno de la tienda y una elegante cafetería en el piso superior similar a un lounge.

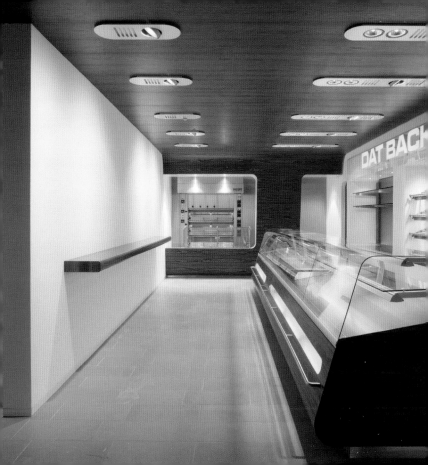

Bar Hamburg

WE LOVE DESIGN

1997
Rautenbergstraße 6-8
St. Georg

www.barhamburg.com
www.welovedesign.net

In der Bar Hamburg vermischen sich eine coole Clubatmosphäre und ein eher privater Lounge-Charakter zum urbanen Erlebnisraum. Das gedämpfte Licht und die bequemen Couchs tragen zum entspannten Gesamteindruck bei.

A cool, club atmosphere and a more private, lounge character combines in Bar Hamburg to create an urban space for adventure. The dimmed lighting and comfortable couches contribute to the overall relaxed impression.

Le Bar Hamburg, combinaison d'atmosphère de club très cool et d'ambiance de salon plutôt privée, est le must des sorties urbaines. La lumière tamisée et les confortables canapés contribuent à créer une impression de décontraction.

El Bar Hamburg es un espacio urbano para las sensaciones resultado de la mezcla de una moderna atmósfera de club con un carácter más bien privado de lounge. La luz atenuada y los cómodos sillones crean la impresión general de relax.

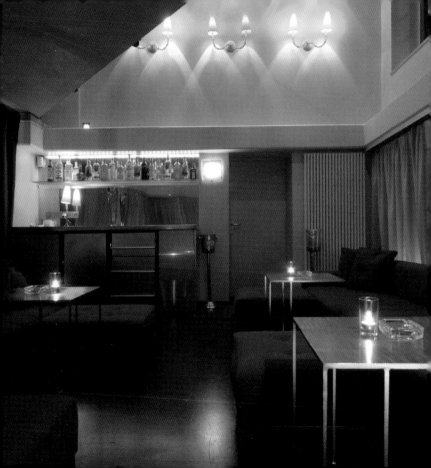

Vivet

SHE_arch

2002
Spitalerstraße 9
Innenstadt

www.she-arch.com

Die Gestalter des Vivet arbeiteten mit raffinierten optischen Tricks: Leicht geknickte Wand- und Deckenteile verschieben die Perspektive des lang gestreckten Restaurants. Der diagonal geteilte Spiegel an der Rückwand erzeugt zudem die Illusion von Unendlichkeit.

The designers of the Vivet worked with refined, optical tricks: slightly curved wall and ceiling parts displace the perspective of the long expanse of restaurant building. The diagonal division of the mirror on the rear wall also produces the illusion of infinity.

Les designers du Vivet ont fait appel à des moyens optiques raffinés : des panneaux de mur et de plafond juxtaposés à angle droit décalent la perspective du restaurant tout en longueur. Le miroir du mur du fond divisé en diagonale crée en outre l'illusion de l'infini.

Los diseñadores del Vivet trabajaron con inteligentes trucos ópticos: la ligera inclinación de algunas partes de las paredes y del techo desplazan la perspectiva de este restaurante de forma alargada. El espejo, dividido diagonalmente, de la pared trasera, crea además la ilusión de infinidad.

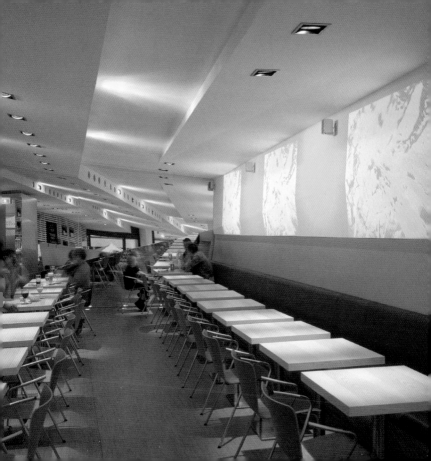

Herzblut

Jordan Mozer and Associates, Ltd.

2002
Reeperbahn 50
St. Pauli

www.herzblut-st-pauli.de
www.mozer.com

Holze und Stoffe in warmen Naturfarben verleihen der Herzblut-Bar eine warme und lebendige Atmosphäre. Zudem wird der Innenraum durch bizarr anmutende Objekte geprägt – diese wurden zunächst als Tonmodelle entwickelt, dann in CAD-Zeichnungen übertragen und schließlich als Gipsformen hergestellt.

Woods and materials in warm, natural colors give the Herzblut Bar a warm and lively atmosphere. In addition, bizarre-looking objects influence the interior —these were developed first of all as clay models, then transferred to computer-assisted design drawings and finally produced as plaster-cast shapes.

Du bois et des étoffes dans des tons naturels chauds confèrent au bar Herzblut une atmosphère vivante et chaleureuse. L'intérieur frappe par sa décoration avec des objets bizarres – ceux-ci ont d'abord été élaborés comme modèles d'argile, puis transcrits en dessins CAO et finalement fabriqués comme moules de plâtre.

Las maderas y las telas en cálidos colores naturales dotan al bar Herzblut de una atmósfera cálida y viva. El interior, además, se caracteriza por sus extravagantes objetos que fueron modelados primeramente en arcilla, trasladados después a dibujos CAD y elaborados finalmente en yeso.

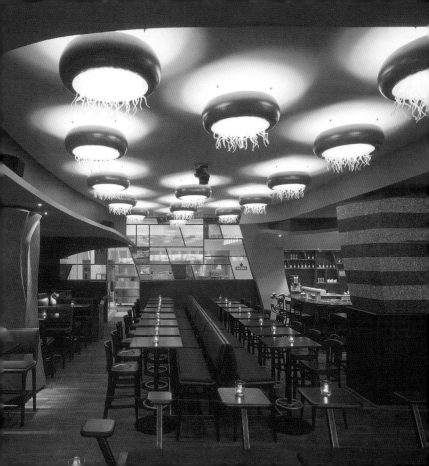

Sands

KBNK Architekten Kähne Birwe Nähring Krause

2002
Mittelweg 26
Rotherbaum

www.kbnk.de

Im Sands erwartet den Gast eine entspannte Atmosphäre. Eine geheimnisvolle holzverkleidete Box inmitten des Gastraums gliedert das Restaurant in verschiedene Zonen. Ruhige Oberflächen und warme Farbtöne harmonieren mit der schlichten, aber eleganten Möblierung des Restaurants.

A relaxing atmosphere confronts the guest at Sands. The restaurant is structured into different zones by a secretive, wooden-clad box in the middle of the guest room. Restful surfaces and warm color tones harmonize with the simple, but elegant furnishing of the restaurant.

L'hôte trouve au Sands une atmosphère décontractée. Un mystérieux cube habillé de bois au milieu de la salle structure le restaurant en différentes zones. Les surfaces planes et les tons chauds s'harmonisent avec l'ameublement simple mais élégant du restaurant.

En el Sands le espera al cliente una atmósfera relajada. Una misteriosa caja revestida con madera divide el espacio en diferentes zonas. Las superficies suaves y los cálidos colores armonizan con el sencillo pero elegante mobiliario del restaurante.

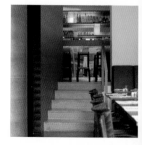

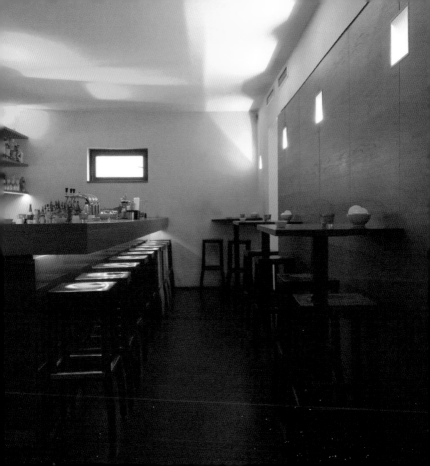

Turnhalle St. Georg

Frank B. Theuerkauf

2003
Lange Reihe 107
St. Georg

www.turnhalle.com

Das Restaurant befindet sich in der sorgfältig renovierten Sporthalle einer Mädchenschule aus dem Jahr 1889. Wo sich früher Schülerinnen am Reck abmühten, werden heute bis zu 200 Gäste in einem hellen, freundlichen Innenraum bewirtet.

The restaurant is located in the carefully renovated sports hall belonging to a girls' school dating from 1889. Today up to 200 guests are served in a bright and friendly interior, where the girls once labored with their exercises at the high-bar.

Le restaurant se trouve dans le gymnase soigneusement rénové d'une école de jeunes filles datant de 1889. Là, où jadis les écolières s'essoufflaient à la barre fixe, quelque 200 hôtes peuvent aujourd'hui se restaurer dans une salle claire et agréable.

El restaurante se encuentra en el gimnasio completamente reformado de un colegio para chicas del año 1889. El lugar donde las niñas se esforzaban en la barra fija, es hoy un espacio interior luminoso y agradable donde se atienden hasta 200 clientes.

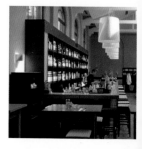

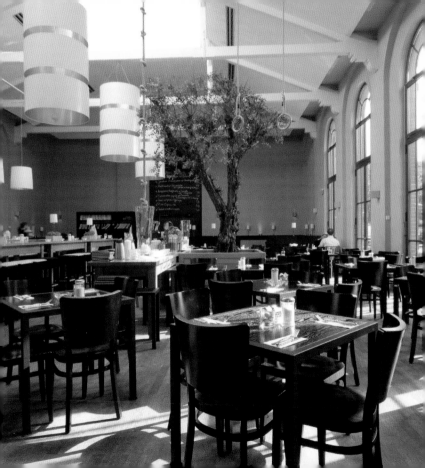

Eisenstein

me di um Architekten Roloff · Ruffing + Partner

1988
Friedensallee 9
Ottensen

www.restaurant-eisenstein.de
www.medium-architekten.de

Die ehemalige Schiffsschrauben-fabrik Theodor Zeise hat sich in den vergangenen Jahren zu einem Zentrum der Hamburger Filmszene entwickelt. Als gastronomischer Mittelpunkt hat sich das Restaurant Eisenstein in einer fast 200 m² großen und 9 m hohen historischen Fabrikhalle etabliert.

In the last few years, the former factory producing screws for shipping, Theodor Zeise, developed into a center of Hamburg's film industry. The Eisenstein Restaurant has established itself as a gastronomic center in a historic factory building, measuring almost 200 m² and 9 m high.

L'ancienne fabrique d'hélices de navire Theodor Zeise est devenue ces dernières années le cœur de la scène cinématographique hambourgeoise. Centre d'attraction gastronomique, le restaurant Eisenstein s'est établi dans un atelier historique de presque 200 m² et 9 m de haut.

La antigua fábrica de hélices de barcos Theodor Zeise se ha convertido, a lo largo de los últimos años, en un escenario importante para el mundo cinematográfico de Hamburgo. El restaurante Eisenstein, alojado en una nave histórica de la fábrica de casi 200 m² y 9 m de altura, se ha establecido como centro gastronómico.

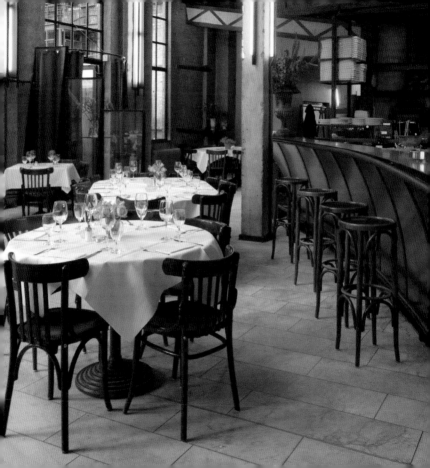

Süllberg Bistro

sw design Synne Westphal

2002
Süllbergterrassen 12
Blankenese

www.suellberg-hamburg.de

Das in Hamburg einmalige, repräsentative Gebäudeensemble auf der Kuppe des Süllbergs existierte seit 1887. Inzwischen wurde die Anlage, zu der auch das elegante Bistro mit über 100 Sitzplätzen gehört, von Grund auf restauriert. Der Glanz der alten Tage wurde so zu neuem Leben erweckt.

The unique, representative building ensemble on the hilltop of the Süllberg has been in Hamburg since 1887. Since then, the property was restored from the foundations—the elegant bistro belongs to the site and seats over 100 guests. This is how new life was breathed into the glory of the old days.

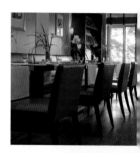

Ce très représentatif complexe immobilier, unique à Hambourg, au sommet du Süllberg, existe depuis 1887. Entre-temps, l'ensemble auquel appartient également l'élégant bistro de plus de 100 places, a été rénové de fond en comble. L'éclat du passé a ainsi pu renaître.

Este conjunto arquitectónico único y representativo situado en la cima del Süllberg en Hamburgo, existe desde 1887. Esta instalación, a la que también pertenece el elegante bistro con más de 100 sillas, ha sido completamente reformada, despertando así nuevamente el brillo de aquellos días.

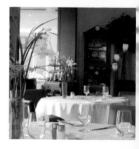

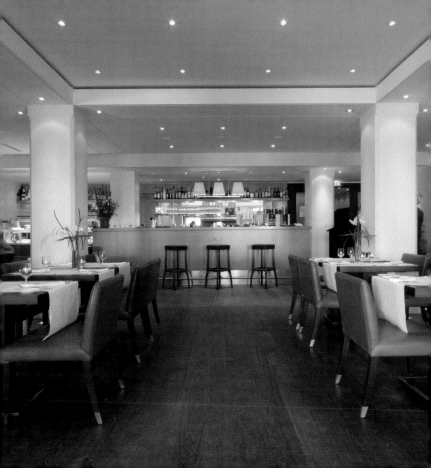

SIDE Spa

Jan Störmer Partner

2001
Drehbahn 49
Innenstadt

www.side-hamburg.de
www.stoermer-partner.de

Kräftige, anregende Farben und klare kubische Formen bestimmen den Wellness-Bereich des SIDE-Hotels. Der hohe Gestaltungsanspruch des Design-Hotels setzt sich in den Räumen des Spas in gleicher Qualität fort.

Strong, stimulating colors and clear, cubic forms determine the fitness area in the SIDE hotel. The high standard in this design hotel is maintained in the spa facilities with the same quality of design.

Des couleurs vives et stimulantes, des formes pures et cubiques caractérisent l'espace remise en forme de l'hôtel SIDE. L'excellence de l'aménagement visée par cet hôtel design se retrouve dans les espaces du Spa au même niveau de qualité.

La zona wellness del hotel SIDE se caracteriza por colores fuertes y estimulantes y unas formas cúbicas de líneas claras. El ambicioso diseño del hotel continúa en las habitaciones del spa sin perder nada de su calidad.

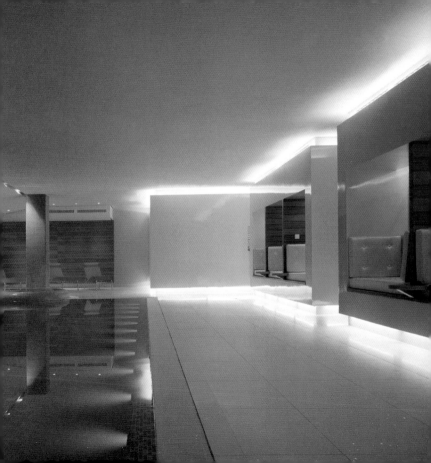

The White Room

Martina & Oliver Reichert di Lorenzen

2003
Große Bleichen 21
Innenstadt

www.the-white-room.com

Alles ist Weiß in dieser exklusiven Lounge für Zahnkosmetik: Wände, Möbel, Accessoires und auch die Behandlungsstühle. Die noble und gleichzeitig entspannte Atmosphäre unterstreicht den Anspruch des White Room als dentalem Wellness-Bereich.

Everything is white in this exclusive lounge for dental cosmetics: walls, furniture, accessories and even the treatment loungers. The elegant and, at the same time, relaxed atmosphere underlines the high standard of the White Room as a dental fitness area.

Tout est blanc dans ce salon exclusif pour la cosmétique des dents : murs, meubles, accessoires mais aussi fauteuils de soins. L'atmosphère à la fois raffinée et décontractée souligne l'orientation mise en forme dentaire du White Room.

En este exclusivo lounge de cosmética dental todo es blanco: las paredes, el mobiliario, los accesorios y los sillones de tratamiento. La atmósfera, elegante y relajada, subraya la pretensión del White Room como espacio para el cuidado dental.

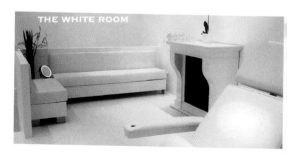

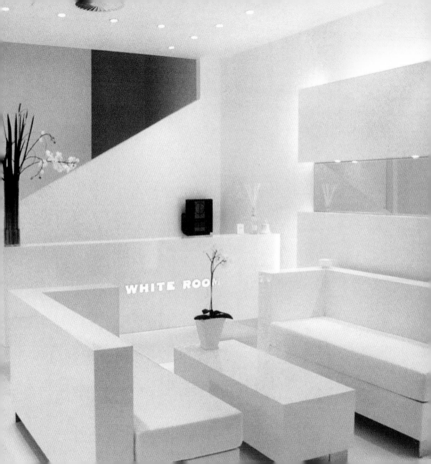

Marlies Möller
Salons Neuer Wall and Alstertal

Dolle + Gross Architekten

2001
Neuer Wall 61
Innenstadt

www.marliesmoeller.de

Wer von einem Friseur nicht nur ein exklusives Ambiente, sondern darüber hinaus auch einen Internet-Zugang am Frisiertisch erwartet, findet dies bei Marlies Möller. Das Design der Salons reicht vom minimalistischen „Zen-Look" bis zu üppig dekorierten Räumen im Kolonialstil.

Anyone who expects not only an exclusive ambiance from his hairdresser's, but also an added extra of internet access at the salon, will find what he's looking for with Marlies Möller. The design of the salon extends from the minimalist "Zen" look to the luxurious decoration of the rooms in colonial style.

Tous ceux qui ne demandent pas seulement à un coiffeur une ambiance particulière mais aussi un accès Internet sur le fauteuil de coiffure le trouveront chez Marlies Möller. Le design des salons va du « look zen » minimaliste aux pièces abondamment décorées en style colonial.

En Marlies Möller al cliente no sólo le espera una peluquería sino, además, acceso a Internet desde el sillón. El diseño de este salón abarca desde el minimalista "zen look" hasta las habitaciones profusamente decoradas en estilo colonial.

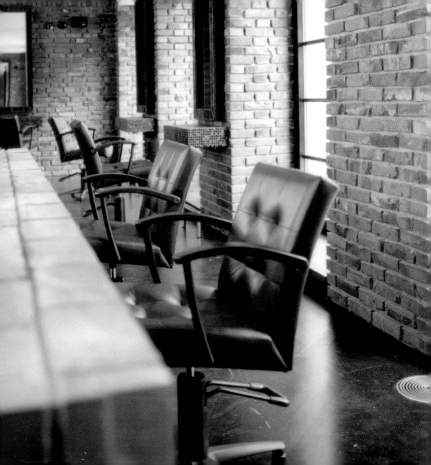

4U

2004
Hans-Henny-Jahn-Weg 21
Winterhude

www.4U-team.com

In einer ehemaligen Fabriketage direkt am Fleet logiert dieser exklusive Salon. In den schlichten, großzügigen Räumen findet sich eine raffinierte Mischung aus Möbeln unterschiedlicher Zeit- und Stilepochen, die man nicht nur bestaunen, sondern auch kaufen kann.

This exclusive salon is housed in a former factory floor, directly on the waterway. In the simple, spacious rooms, there is a refined mix of furniture from different periods and genres that you cannot only admire, but also purchase.

Ce salon exclusif occupe un étage d'une ancienne usine directement au bord d'un canal. Dans les pièces simples et spacieuses se trouve un mélange raffiné de meubles d'époques et de styles différents que l'on peut non seulement admirer mais aussi acheter.

Este exclusivo salón está situado en una planta de una antigua fábrica ubicado directamente en un "Fleet" (canal). En los espacios, sencillos y amplios, encontramos una refinada mezcla de muebles de diferentes épocas y estilos que no sólo se pueden admirar sino también comprar.

Holmes Place Lifestyle Club

SEHW ARCHITEKTEN

2003
Bostelreihe 2
Barmbek

www.sehw.de

Der Holmes Place ist mit ca. 5.500 m² eines der größten Fitness-Studios in Deutschland. Die verschiedenen Bereiche des Clubgebäudes sind durch verglaste Öffnungen in Wänden und Decken optisch miteinander verknüpft. Im Zusammenspiel mit der sorgfältigen Farb- und Materialwahl entstanden spannungsvolle Innenräume.

Holmes Place has approx. 5,500 m² of space and this makes it one of the largest fitness studios in Germany. The different areas of the club building are optically linked with each other by glass openings in the walls and ceilings. Exciting interiors were created in interplay with the careful selection of color and materials.

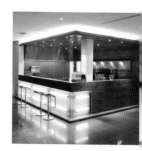

Avec ses 5.500 m², le Holmes Place est le centre de fitness le plus grand d'Allemagne. Les différentes sections du bâtiment sont reliées visuellement entre elles par des ouvertures vitrées dans les murs et les plafonds. La conjugaison de matériaux et de couleurs minutieusement choisis a créé des intérieurs surprenants.

El gimnasio del Holmes Place es, con sus casi 5.500 m², uno de los más grandes de Alemania. Las diferentes áreas del edificio del club están unidas entre sí óptimamente a través de aberturas acristaladas en los tabiques y techos. La combinación de los colores y materiales escogidos crearon vibrantes espacios interiores.

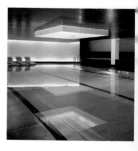

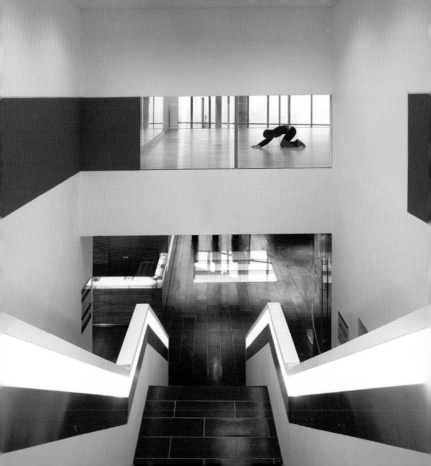

Sportfive Loge

Studio Andreas Heller GmbH

2001
Sylvesterallee 7
Bahrenfeld

www.hsv.de
www.studio-andreas-heller.de

Die Sportfive Lounge in der AOL-Arena bietet – selbstverständlich – einen optimalen Blick auf das Geschehen im Stadion. Mit einem großen Konferenztisch ausgestattet wird die Lounge regelmäßig für repräsentative Zwecke, Aufsichtsratssitzungen des HSV oder Vertragsunterzeichnungen genutzt.

The Sportfive Lounge in the AOL Arena offers—naturally—an optimal view of what's going on in the stadium. The lounge is equipped with a large conference table and regularly used for representative purposes, board of directors' meetings of the Hamburg Sports' Club (HSV) or for signing contracts.

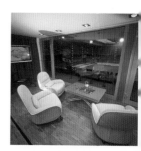

Le Sportfive Lounge du stade AOL offre – bien sûr – une vue optimale sur ce qui se passe dans le stade. Equipé d'une grande table de conférence, le salon est régulièrement utilisé à des fins de représentation, pour les réunions du conseil d'administration du club du football HSV ou pour la signature de contrats.

El Sportfive Lounge del estadio AOL ofrece, naturalmente, una excelente vista sobre los acontecimientos en el estadio. El lounge, equipado con una amplia mesa de conferencias, se emplea regularmente con fines representativos, reuniones del consejo de administración del HSV o firmas de contratos.

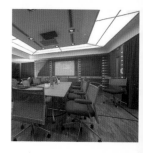

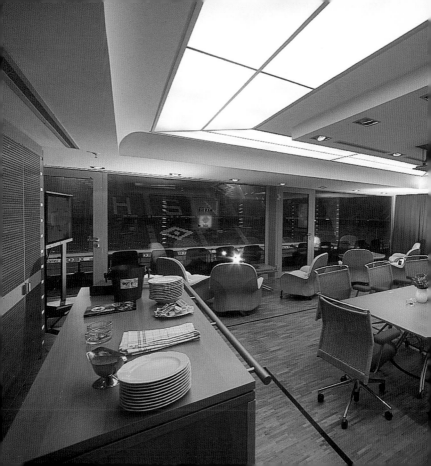

Elixia

vhp gmbh von Have & Partner
SÖNNICHSEN +

1999
Gasstraße 2
Bahrenfeld

www.elixia.de
www.vhpgmbh.de

Zur Ausstattung des attraktiven Clubs gehören die Angebote eines klassischen Fitness-Studios sowie ein umfangreicher Wellnessbereich. Die „trendige" Atmosphäre der Sportbereiche steht in reizvollem Kontrast zur historischen Architektur des alten Industriegebäudes.

The products offered by a classic fitness studio and an extensive treatment area belongs to the attractive club's facilities. The "trendy" atmosphere of the sports' areas is a delightful contrast to the historic architecture of the old, industrial building.

Les équipements de ce club attrayant comprennent les prestations d'un centre de fitness classique et une large zone de remise en forme. L'atmosphère très tendance des sections sport contrastent agréablement avec l'architecture historique du vieux bâtiment industriel.

En la oferta de este interesante club se incluye un clásico gimnasio y una amplia zona de wellness. La "moderna atmósfera" del gimnasio establece un interesante contraste con la arquitectura histórica del viejo edificio industrial.

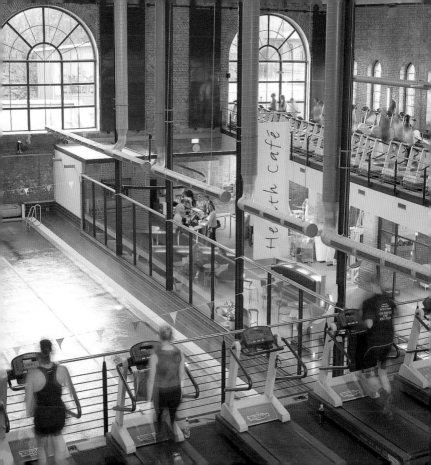

Kunsteis- und Radrennbahn
Skating Rink and Cycling Racetrack

ASW Architekten Silcher Werner + Redante
Schlaich Bergermann und Partner

1994
Hagenbeckstraße 124
Stellingen

www.sbp.de

Eine minimierte Konstruktion aus vier 20 m hohen Hauptstützen und acht seilunterspannten Luftstützen trägt das Membrandach der Kunsteis- und Radrennbahn. Das an ein Zelt erinnernde Dachtragwerk wurde nachträglich über der vorhandenen Sportanlage errichtet.

A minimal construction of four 20 m high main supports and eight aerial wire supports, which are suspended from the roof on wires, carries the membrane roof of the skating rink and cycling racetrack. The roof supports, which are reminiscent of a tent, were added in afterwards above the existing sports' facility.

Une construction minimisée constituée de quatre poteaux principaux de 20 m de haut et de huit poteaux suspendus soustendus par des haubans supporte la toiture à membrane de la patinoire et vélodrome. La structure qui ressemble à une tente a été construite au-dessus des équipements sportifs existants.

Una construcción minimizada de cuatro pilares principales de 20 m de altura y ocho columnas de aire sujetadas con cables por debajo del tejado, soporta el techo de membrana de la pista de hielo artificial y velódromo. La cubierta, que evoca una tienda de campaña, se colocó con posterioridad sobre la instalación.

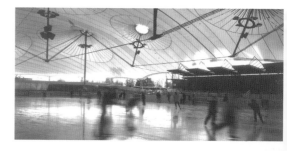

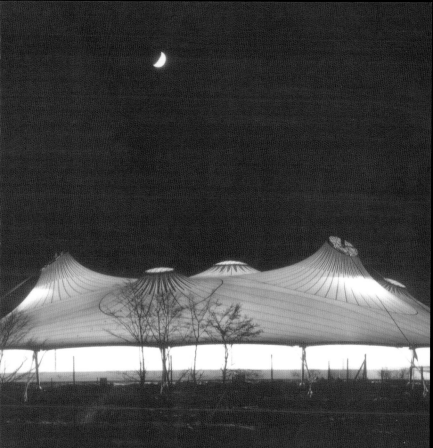

to shop . mall
 retail
 showrooms

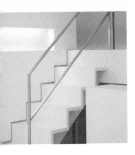
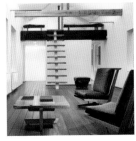
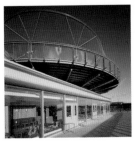
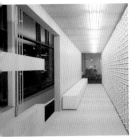
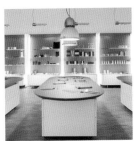
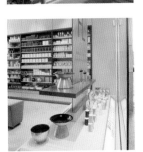
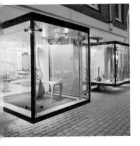
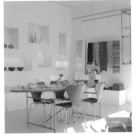

Alsterhaus

Christian F. Heine Architekten
WTM Windels Timm Morgen

2005
Jungfernstieg 16-20
Innenstadt

www.alsterhaus.de
www.heine-architekten.de
www.wtm-ingenieure.de

Das Alsterhaus gilt seit fast einem Jahrhundert als eine Hamburger Institution. Durch eine aufwändige Renovierung wurde nun die alte Schönheit des Hauses wiederhergestellt. Ellipsenförmige Öffnungen in allen Ebenen ermöglichen einen Durchblick vom Erdgeschoss bis zur farbigen Glasdecke über dem vierten Obergeschoss.

The Alster house has been regarded as a Hamburg institution for almost a century. The building's former beauty was reinstated by complicated renovation work. Elliptical openings that are the same on all levels makes it possible to look right up from the ground floor level to the colorful glass ceiling above the upper fourth floor.

L'Alsterhaus passe pour une institution hambourgeoise depuis presque un siècle. Une rénovation d'envergure a maintenant redonné son ancienne beauté à cet établissement. Des ouvertures en forme d'ellipse à tous les niveaux permettent de voir du rez-de-chaussée la verrière colorée au-dessus du quatrième étage.

En Hamburgo, la Alsterhaus está considerada desde hace casi un siglo como una institución. Con la completa reforma se consiguió restaurar la antigua belleza de la casa. Una abertura elíptica en todas las plantas permite mirar desde la planta baja hasta la cubierta de cristal coloreado del cuarto piso.

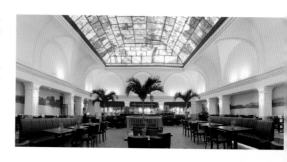

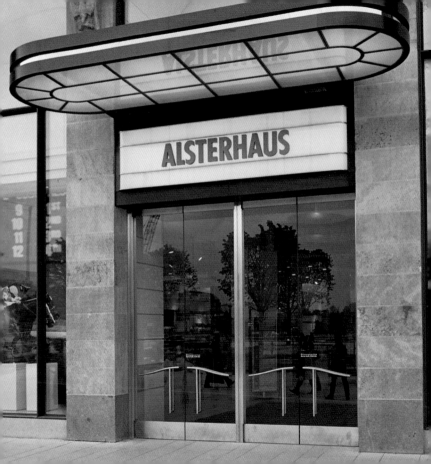

Petra Teufel GmbH & Co. KG

Kleffel Köhnholdt Papay Warncke Architekten

1997
Neuer Wall 43
Innenstadt

www.petrateufel.de
www.kkpw.de

Eine raffinierte Kombination von Alltags- und Edelmaterialien prägt das zweigeschossige Modegeschäft am Neuen Wall. Das besondere Augenmerk der Architekten lag auf der sorgsamen Ausarbeitung der Innenraumdetails.

A refined combination of everyday and precious materials influences the two-storey fashion store on the Neuen Wall. The architects' attention was especially devoted to a careful exposition of detail in the interior.

Un mélange raffiné de matériaux nobles et usuels caractérise ce magasin de mode à deux étages sur l'avenue Neuer Wall. Les architectes ont accordé une importance particulière à l'élaboration soignée des détails de l'aménagement intérieur.

El interior de esta tienda de moda de dos plantas situada en Neuen Wall, se caracteriza por una inteligente combinación de materiales corrientes y nobles. Los arquitectos pusieron especial atención en una esmerada elaboración de los detalles del espacio interior.

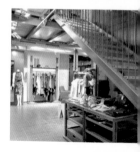

Petra Teufel

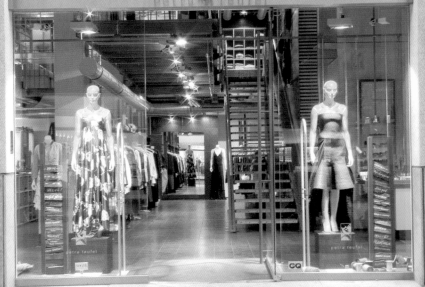

Windsor

Petzinka Pink Architekten I Technologische Architektur®

2000
Neuer Wall 20
Innenstadt

www.windsor.de
www.petzinka-pink.de

Eleganz, Purismus und Under- statement sind Werte, die das Münchner Modelabel auch im Design seiner Läden vermittelt. Die noble, auf wenige Farben und Materialien reduzierte Innen- ausstattung ist in klaren Linien arrangiert.

Elegance, purism and under- statement are the values that the Munich-based fashion label also expresses in the design of its stores. The noble interior design that is kept to a minimum of col- ors and materials is arranged in clear lines.

Elégance, purisme et retenue britannique sont des valeurs que la marque de mode munichoise s'attache à transmettre jusque dans le design de ses magasins. La décoration intérieure noble, réduite à quelques couleurs et matériaux s'organise sur des li- gnes pures.

La elegancia, el purismo y la so- briedad son los valores que la marca de moda muniquesa transmite también en el diseño de sus tiendas. La decoración interior, elegante y reducida a pocos colores y materiales, se ha organizado siguiendo unas líneas claras.

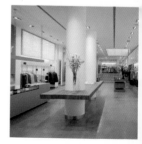

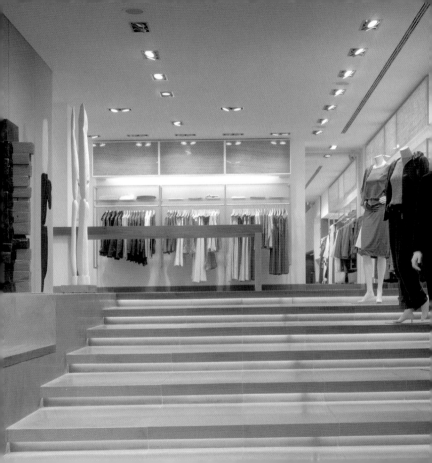

Harald Lubner
Feinste Düfte und Seifen

Hennings Börn Interiors

2000
Große Bleichen 23
Innenstadt

www.hennings-boern.de

Der nur 35 m² große Shop hält ein ausgewähltes Angebot an Düften, Seifen und exklusivem Räucherwerk bereit. Glas, Edelstahl und fliederfarbene Einbauten schaffen ein reduziertes, beinahe minimalistisches Umfeld.

The shop that measures 35 m² only stocks an exclusive range of perfumes, soaps and luxury aromatic products. Glass, stainless steel and lilac-colored installations create a reduced, almost minimalist environment.

La boutique de seulement 35 m² présente une sélection raffinée de parfums, savons et encens exclusifs. Verre, acier inoxydable et aménagements mauves créent un environnement réduit quasi minimaliste.

Esta tienda de sólo 35 m² ofrece un escogido surtido de aromas, jabones y exclusivos productos aromáticos para quemar. El cristal, el acero y los módulos de color lila crean un entorno reducido casi minimalista.

Karstadt Sport

Christian F. Heine Architekten
WTM Windels Timm Morgen

1999
Lange Mühren 14
Innenstadt

www.heine-architekten.de
www.wtm-ingenieure.de

Das wohl größte Sportkaufhaus Europas bietet seinen Kunden eine ganze Reihe spektakulärer Attraktionen. So befindet sich auf dem Dach eine kreisrunde Sportanlage, die im Winter als Kunsteisbahn, im Sommer jedoch als Arena für verschiedene Sportarten genutzt wird und von einer Tartanlaufbahn umgeben ist.

Probably the largest sportswear store in Europe offers its customers a whole series of spectacular attractions. This is how a circular sporting facility came to be located on the roof,—it can be used as a skating rink in the winter and in the summer provides an arena for different sports, as well as being surrounded by a tartan-colored racetrack.

Le magasin de sport sans aucun doute le plus grand d'Europe propose à ses clients toute une série d'attractions spectaculaires. On trouve ainsi sur le toit un terrain de sport circulaire qui devient une patinoire en hiver et une arène en été pour pratiquer différents sports et qui est entourée d'une piste de tartan.

La superficie comercial dedicada al deporte más grande de Europa ofrece a sus clientes toda una serie de espectaculares atracciones. En la azotea hay una instalación deportiva que en invierno se emplea como pista de hielo artificial y en verano, como estadio para diferentes tipos de deporte rodeada por una pista de tartán.

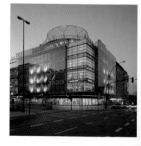

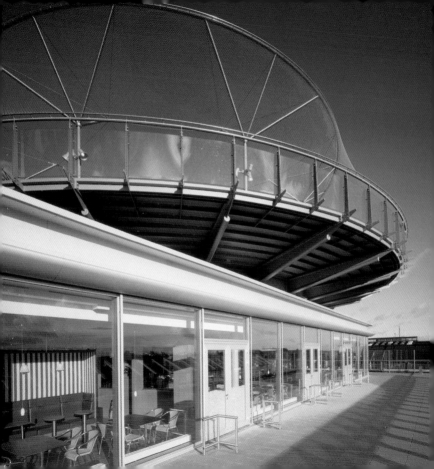

Freitag Flagshipstore

blauraum architekten

2004
Klosterwall 9
Innenstadt

www.freitag.ch
www.blauraum.de

Die Schweizer Firma stellt Umhängetaschen aus gebrauchten LKW-Planen her. Im Zentrum des Flagship-Stores steht eine offene Box in den Dimensionen eines Standard-Containers, in dem jeder Kunde aus der Vielzahl der Unikate seine persönliche Tasche aussuchen kann.

The Swiss company produces shoulder bags from used trucks' tarpaulins. In the center of the flagship store, an open box is located in the dimensions of a standard container, where every client can pick out his personal bag from the variety of one-off items.

Cette société suisse fabrique des sacs à bandoulière à partir de vieilles bâches de camions. Au centre du magasin porte-drapeau se tient une caisse ouverte aux dimensions d'un conteneur standard dans lequel chaque client peut choisir son sac personnel parmi une grande variété d'exemplaires uniques.

La firma suiza fabrica bolsos de bandolera a partir de las lonas usadas de los camiones. En el centro de la Flagship-Store se ha colocado una caja abierta con las medidas de un contenedor estándar. En ella los clientes pueden buscar su bolsa de entre un gran número de ejemplares únicos.

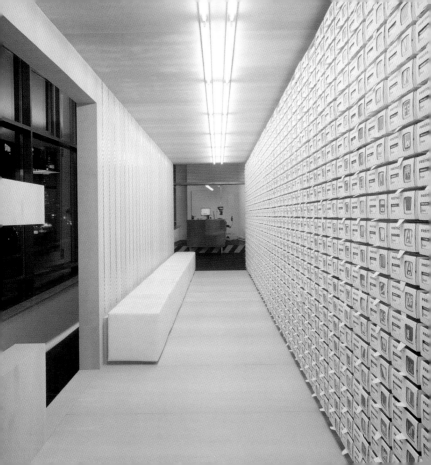

Current Affairs

lw_architects Dietmar Leyk, Petra Wollenberg

2004
Weidenstieg 5a
Eimsbüttel

www.lwarchitects.de

Großformatige Lederpanele bilden Rückwand und Decke für den Showroom einer Mode- und einer Schmuckdesignerin. Ein schmaler Gang zwischen dem Showroom und den Werkstätten dient als integrierter „Catwalk", auf dem sich die Kundinnen mit wenigen Schritten in Models verwandeln.

Large-scale leather panels form the rear wall and ceiling for the showroom of a fashion and a jewelry designer. A narrow walkway between the showroom and workshops serves as an integrated "catwalk", where customers are turned into models after only a few steps.

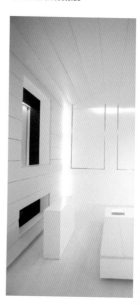

Des panneaux de cuir grand format composent le mur du fond et le plafond du showroom d'une styliste de mode et d'une créatrice de bijoux. Un étroit passage relie le showroom avec les ateliers, tel un « podium » intégré sur lequel les clientes, en quelques pas, se transforment en mannequins.

Unos paneles de cuero de gran formato forman la pared posterior y el techo de esta sala de exposiciones de una diseñadora de moda y joyas. Un pasillo estrecho entre la sala y los talleres actúa como pasarela integrada sobre la que las clientas se convierten en pocos pasos en modelos.

172

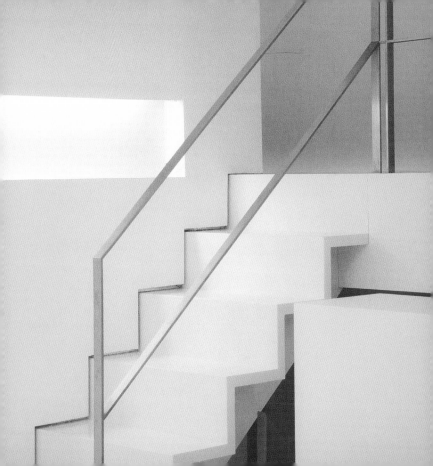

craft2eu

Philipp von Gwinner

2004
Eppendorfer Weg 231
Eppendorf

www.craft2eu.net

craft2eu versteht sich als Agentur und Ladengalerie für europäisches Kunsthandwerk und Design. Ausgewählte Einzelstücke und Kleinserien werden in beleuchteten Wandnischen auf einfache, aber effektvolle Weise inszeniert.

Craft2eu considers itself as an agency and shopping gallery for European artwork and design. Exclusive, individual items and limited editions are displayed in illuminated wall niches in a simple, yet effective way.

craft2eu est une agence et une galerie de vente pour l'artisanat d'art et le design européens. Des exemplaires uniques choisis et des objets fabriqués en petites séries sont mis en valeur dans des niches murales par une mise en scène des éclairages simple et efficace.

craft2eu se ve a sí misma como una agencia y tienda-galería para el arte y el diseño europeos. Piezas individuales y pequeñas series escogidas son presentadas en unos sencillos nichos en las paredes con una iluminación sencilla pero efectista.

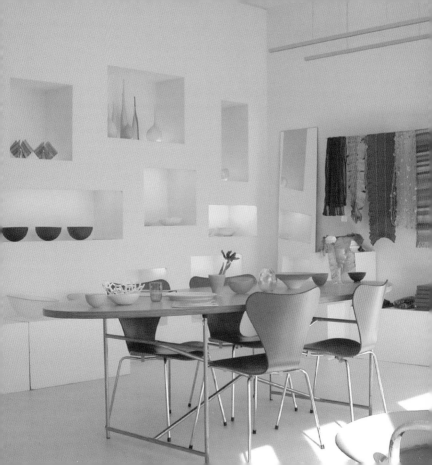

Colleen B. Rosenblat
Jewelry Design

GABELLINI ASSOCIATES LLP
George Nakashima

1998
Mittelweg 49a
Harvestehude

www.rosenblat.de
www.gabelliniassociates.com
www.nakashimawoodworker.com

Eine Remise aus dem Jahr 1890 verwandelte sich zum extravaganten Showroom einer Schmuckdesignerin. Der historische Bau wurde dafür auf seine ursprüngliche, einfache Struktur zurückgebaut. Stein und Holz sind die prägenden Materialien der Innenraumgestaltung.

A barn was transformed into an extravagant showroom for a jewelry designer. The historical building was returned to its original, simple structure for that very purpose. Stone and wood are the predominant materials used for the interior design.

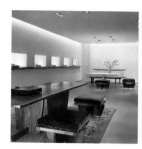

Un dépôt datant de 1890 est devenu l'extravagant show-room d'une créatrice de bijoux. Pour ce faire, le bâtiment historique a retrouvé sa structure simple d'origine. La pierre et le bois sont les matériaux dominants de la décoration intérieure.

Una cochera del año 1890 fue transformada en una extravagante sala de exposiciones de una diseñadora de joyas. Para ello se recuperó la sencilla estructura histórica originaria. La piedra y la madera son los materiales que caracterizan el diseño del espacio interior.

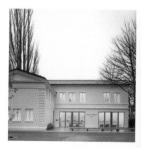

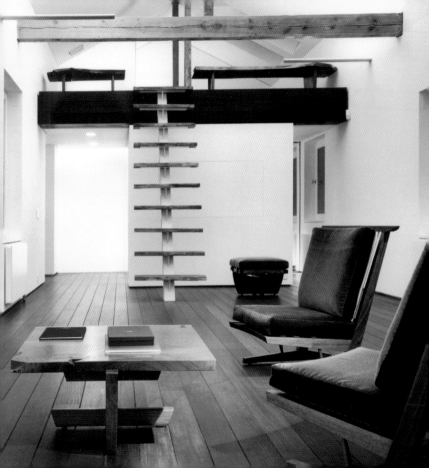

Galerie Nikou

Stoeppler + Stoeppler Architekten BDA

2000
Sierichstraße 46
Winterhude

www.stoeppler-architekten.de

Ein Ladengeschäft wurde zu einer Galerie umgebaut. Dabei zeigte sich, dass die vorhandenen, relativ kleinen Fassadenöffnungen nicht vergrößert werden konnten. Die Architekten machten aus der Not eine Tugend und schufen anstelle normaler Schaufenster zwei weit auskragende Glasvitrinen als außergewöhnlichen Blickfang.

A retail shop was remodeled into a gallery. It emerged in the process that the existing, relatively small window cavities could not be enlarged. The architects made the best of it and instead of a normal showcase window, they created two glass windows, projecting far outwards and making an extraordinarily eye-catching feature.

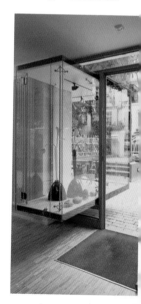

Un magasin devait se transformer en galerie. Il s'est avéré alors que les ouvertures existantes, relativement petites, ne pouvaient être agrandies. Faisant contre mauvaise fortune bon cœur et au lieu de construire des vitrines normales, les architectes ont créé des cubes de verre dépassant de la façade, assez exceptionnels pour accrocher le regard.

Aquí una tienda fue transformada en una galería. Durante el proceso de la reforma se vio que no era posible ampliar las aberturas, relativamente pequeñas, existentes en la fachada. Los arquitectos hicieron de esta necesidad una virtud creando, en vez de un escaparate normal, dos vitrinas de cristal muy sobresalientes para captar la atención.

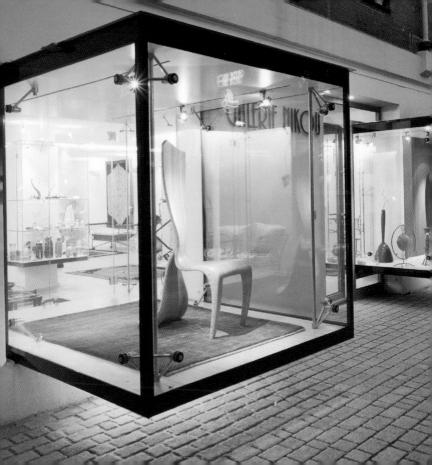

Berendsohn AG

Christian Werner Industrial Design

2001
Rissener Landstraße 252
Rissen

www.christian-werner.com

Das Unternehmen für hochwertige Geschenkartikel und Werbemittel wünschte einen Showroom für interne Präsentationen und Schulungen. Die unterschiedlichen Nutzungen und die ausgesprochen breite Produktpalette der Firma verlangten nach einer flexiblen Ausstattung, die den jeweiligen Bedürfnissen angepasst werden kann.

The company for high-quality gifts and advertising materials wanted a showroom for internal presentations and training purposes. The different uses and the firm's decidedly wide product range demanded a flexible interior that can be adapted to meet the respective needs.

L'entreprise de cadeaux et d'articles publicitaires haut de gamme souhaitait une salle de démonstration pour des présentations et des formations internes. Les utilisations multiples et la gamme de produits étendue de la société exigeaient un aménagement modulable pouvant être adapté aux besoins ponctuels spécifiques.

La empresa fabricante de artículos de regalo exclusivos y de material publicitario quería una sala de exposiciones para las presentaciones internas y los cursos de formación. Los diferentes usos del espacio y una gama de productos especialmente amplia, requerían un equipamiento flexible que pudiera adaptarse a todas las necesidades.

180

Index Architects / Designers

Index Architects / Designers

Index Structural Engineers

Index Districts

Index Districts

187

Photo Credits

Imprint

Copyright © 2005 teNeues Verlag GmbH & Co. KG, Kempen

Published by teNeues Publishing Group

teNeues Book Division
Kaistraße 18
40221 Düsseldorf, Germany
Phone: 0049-(0)211-99 45 97-0
Fax: 0049-(0)211-99 45 97-40
E-mail: books@teneues.de

teNeues Publishing Company
16 West 22nd Street
New York, N.Y. 10010, USA
Phone: 001-212-627-9090
Fax: 001-212-627-9511

teNeues France S.A.R.L.
4, rue de Valence
75005 Paris, France
Phone: 0033-1-55 76 62 05
Fax: 0033-1-55 76 64 19

Press department: arehn@teneues.de
Phone: 0049-(0)2152-916-202

www.teneues.com
ISBN-10: 3-8327-9078-0
ISBN-13: 978-3-8327-9078-3

teNeues Publishing UK Ltd.
P.O. Box 402
West Byfleet
KT14 7ZF, UK
Phone: 0044-1932-403 509
Fax: 0044-1932-403 514

teNeues Iberica S.L.
Pso. Juan de la Encina 2–48,
Urb. Club de Campo
28700 S. S. R. R., Madrid, Spain
Phone: 0034-91-65 95 876
Fax: 0034-91-65 95 876

Bibliographic information published by Die Deutsche Bibliothek
Die Deutsche Bibliothek lists this publication in the Deutsche Nationalbibliografie;
detailed bibliographic data is available in the Internet at http://dnb.ddb.de

Concept of and:guides by Martin Nicholas Kunz

Edited by Christian Datz and Christof Kullmann
Layout & Pre-press: Thomas Hausberg
Imaging: Jan Hausberg
Map: go4media. – Verlagsbüro, Stuttgart

Translation: SAW Communications,
Dr. Sabine A. Werner, Mainz
English: Dr. Suzanne Kirkbright
French: Brigitte Villaumié
Spanish: Silvia Gómez de Antonio

fusion-publishing stuttgart . los angeles www.fusion-publishing.com

Printed in Italy

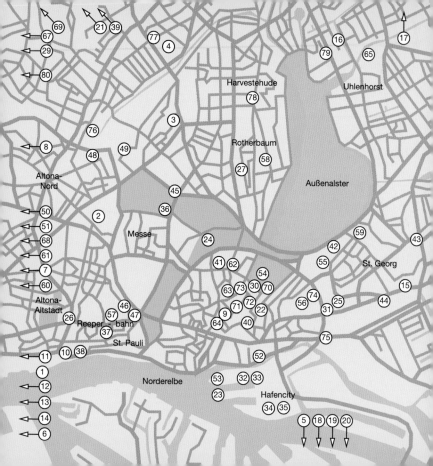

Legend

(28) →

and : guide

Size: 12.5 x 12.5 cm / 5 x 5 in. (CD-sized format)
192 pp., Flexicover
c. 200 color photographs and plans
Text in English, German, French, Spanish

Other titles in the same series:

Amsterdam
ISBN: 3-8238-4583-7
Barcelona
ISBN: 3-8238-4574-8
Berlin
ISBN: 3-8238-4548-9
Chicago
ISBN: 3-8327-9025-X
Copenhagen
ISBN: 3-8327-9077-2
London
ISBN: 3-8238-4572-1
Los Angeles
ISBN: 3-8238-4584-5
Munich
ISBN: 3-8327-9024-1

New York
ISBN: 3-8238-4547-0
Paris
ISBN: 3-8238-4573-X
Prague
ISBN: 3-8327-9079-9
San Francisco
ISBN: 3-8327-9080-2
Shanghai
ISBN: 3-8327-9023-3
Tokyo
ISBN: 3-8238-4569-1
Vienna
ISBN: 3-8327-9026-8

To be published in the same series:

Dubai
Dublin
Hong Kong
Madrid
Miami

Moscow
Singapore
Stockholm
Sydney
Zurich

teNeues

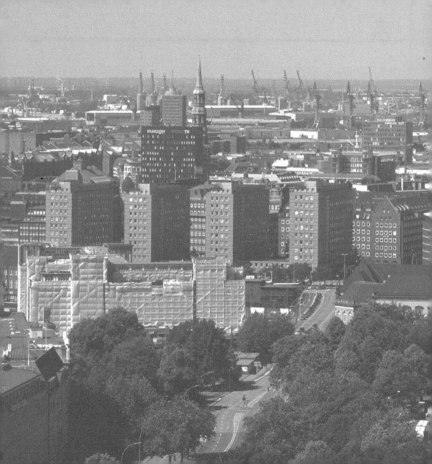